Draw & Paint
Fairies
In Watercolour

SARA BURRIER

Search Press

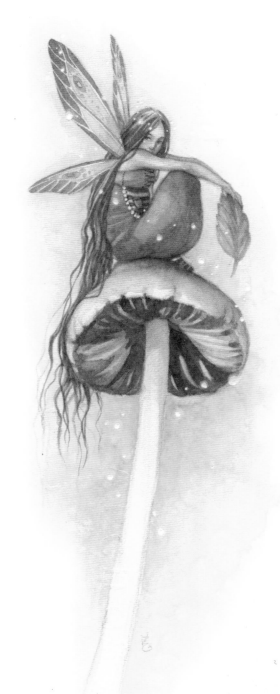

DRAW & PAINT
Fairies
IN WATERCOLOUR

A QUARTO BOOK

Published in 2014 by Search Press Ltd
Wellwood
North Farm Road
Tunbridge Wells
Kent TN2 3DR

ISBN 978-1-78221-100-6

Conceived, designed and produced by
Quarto Publishing plc
The Old Brewery
6 Blundell Street
London N7 9BH

QUAR.DRF

Project Editor: Victoria Lyle
Art Editor: Emma Clayton
Designer: Karin Skånberg
Copyeditor: Sarah Hoggett
Proofreader: Ruth Patrick
Indexer: Helen Snaith
Picture Researcher: Sarah Bell
Art Director: Caroline Guest

Creative Director: Moira Clinch
Publisher: Paul Carslake

Colour separation in Hong Kong by
Cypress Colours (HK) Ltd

Manufactured in China by
1010 Printing International Ltd

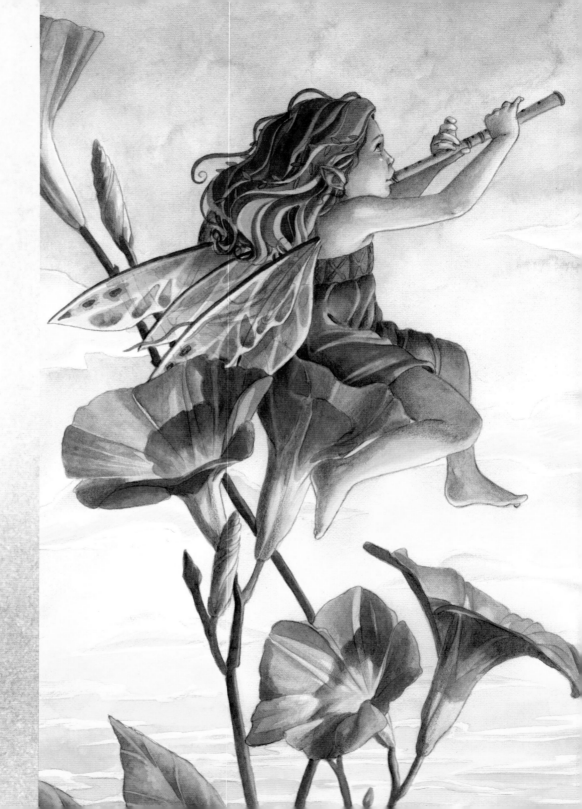

Contents

Rules for drawing

Rules for watercolour

Other artists' rules

My fairy world

Fairies entice me with their magical spirit, ethereal light and deep treasury of character. They display a wide range of emotions, making playful faces and body gestures, much like I do, and I can relate to them in this way. In my work I reflect these unique qualities and the unlimited possibilities of the imagination.

I began to truly admire and follow fairies when I was very little. I spent many days outdoors finding little nooks under bushes trees to climb, and streams to soak my feet in, imagining I was some place else, some place very magical where you can talk to animals. It wasn't long after I saw the frost fairies from Disney's film *Fantasia* that I began to see nature differently and my imagination soared with all kinds of fantastical ideas, especially about how fairies looked and acted.

Translating the beauty I find around me requires a medium that allows my drawing to work with it, since more than half of the art, and idea, is the drawing itself. I also need a medium that I can have lots of control over, but that also performs some of the work for me. Watercolour allows many glazes while still sharing the drawing underneath, and provides soft and bold colours, lots of light and many different textures through play. It always surprises me with its possibilities and has a very magical quality that I feel translates fairies and their world with depth.

Much like the music of songbirds and the Celtic fiddle, gorgeous classical art and pattern, watercolour excites and fascinates me, inspiring me to create and paint, always learning something new.

Sara B

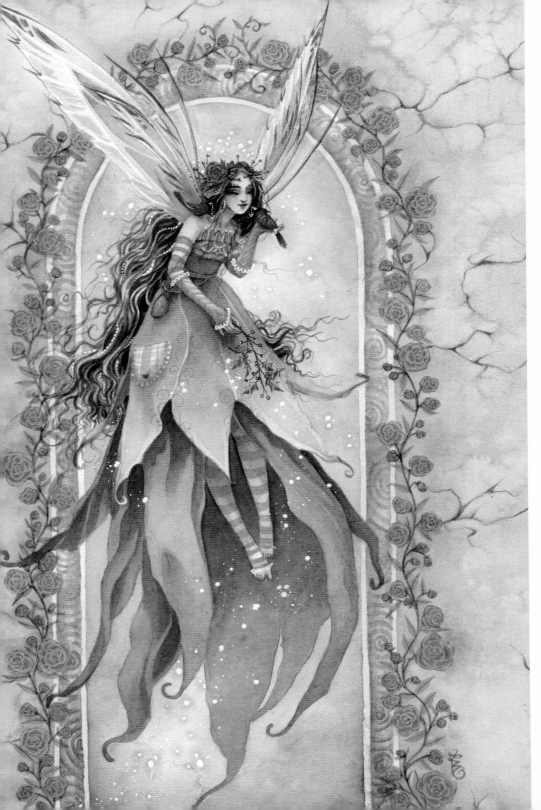

◄ Cardinal Fairy displays beautiful regency in her appearance and in the choice of colour. Mint and coral create a crisp colour palette, chosen to give a bold contrast between the wall and the fairy herself. She shows she isn't restricted, but is free to love.

↖ Porcini and her blue-green colour palette always draw me in. It's very light and airy, my preferred environment. I also adore her playful pose with pointed-in toes, hands at the back and soft grin.

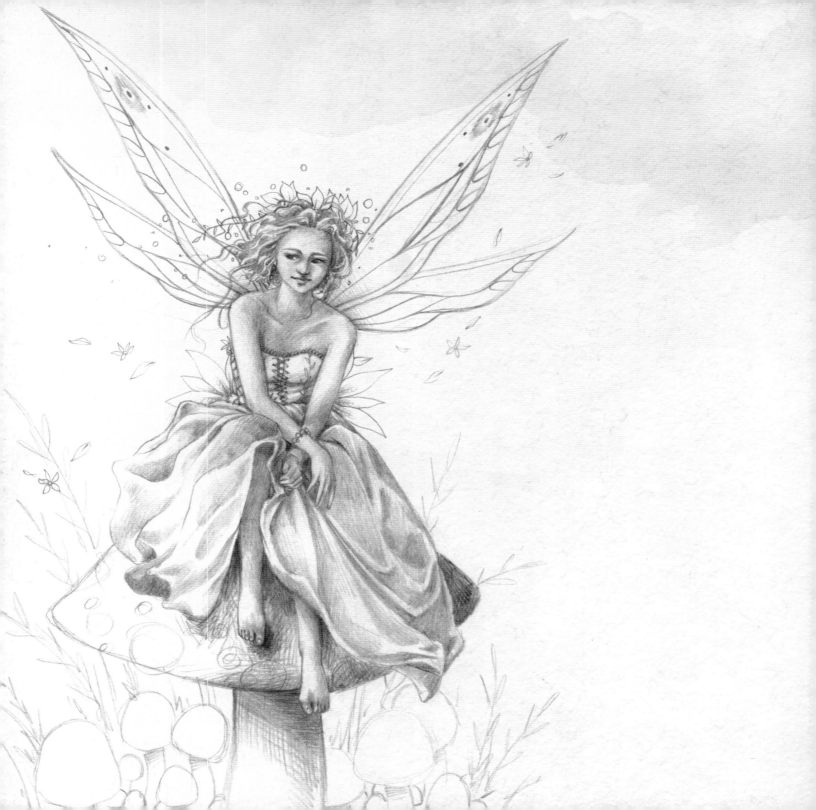

Rules for drawing

Discover the qualities of the basic tools and materials needed to start drawing and how to manage your many inspirations. Learn fundamentals such as gesture, proportions and anatomy to create a believable character using fun fairy poses, costumes, and hairstyles. Move on to advance your understanding of the principles of composition, environment and lighting to create a final drawing full of story.

Drawing tools & materials

Every artist starts with their art box filled with drawing materials, and there are many to choose from. Having a wide range of tools will allow you to explore and discover what works best for creating dark lines, rays of light or the velvety texture of a dress. Every artist is different in his or her approach to drawing; therefore, the tools that work for each will be different. Experiment to find the best tools for *your* fairy drawing.

Setting up your workspace

To start, prepare your workspace so that you have everything you need to begin creating. Place your drawing pencils on the side you write with, any reference material on the opposite side and above your paper and your paper or sketchbook in the middle. If you have a table that can angle up, prop it up and secure your references with tape. You will need pencils, erasers, references, paper and possibly a ruler, drafting brush and templates.

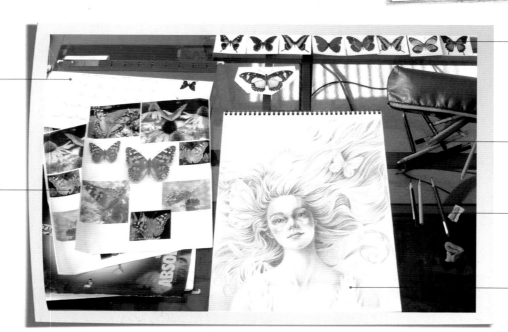

Pile of possible references needed throughout drawing, easy access.

Reference material placed on the opposite side to the drawing materials.

Multiple variations and colour choices taped to the very top for more inspiration and design ideas.

Coloured pencils ready for use above graphite mechanical pencils. All extra drawing materials can be placed above as needed.

Drawing pencils, ruler, eraser and sharpener on side of drawing hand for easy access throughout the drawing process.

Drawing pad/paper placed in centre of workspace.

Graphite pencils

Graphite pencils are classed in different grades, and the grade is marked with a number and a letter on the pencil or lead itself. The letter 'B' stands for 'black' and the letter 'H' stands for 'hard'. The number next to the letter 'B' or 'H' determines how black or how hard the pencil lead is. They graduate from very soft leads for shading and dark mark making to very hard leads that will provide light, small marks that are great for details. Many pencil sets include a mix of 'B' and 'H' pencils to start with. Each weight of pencil is capable of producing a wide variety of marks, depending on how it is held and used – you can create a line that varies from thick and dark to thin and light with one sweep of one pencil! Having a wide range will allow you to explore what works best for you as an artist – every artist is different in his or her approach to drawing.

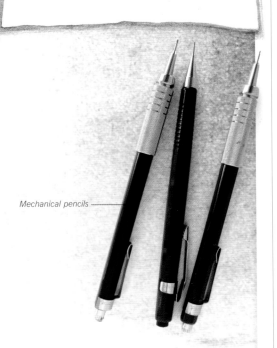

Mechanical pencils

HARD LEAD PENCILS

Use lead grades 6H, 2H and H for detail or final work. These leads are best to use under watercolour if you don't want to have much of the graphite or grey residue washed into your colour. Their lines are meant to be light, precise and extra fine.

PRESSURE HEAVY TO LIGHT

6H 2H H

CROSSHATCHING

6H 2H H

DETAIL DRAWING

6H 2H H

SOFT LEAD PENCILS

Use soft lead grades such as 6B, 2B and HB for sketching and pencil drawings, and when you need the darkest darks; something that will smudge easily for blending, or rough, textured lines. If watercolour is painted over the top of soft pencil, some of the graphite will lift up and grey your colours.

PRESSURE HEAVY TO LIGHT

6B 2B HB

CROSSHATCHING

6B 2B HB

DETAIL DRAWING

6B 2B HB

To achieve the blackest shadows in her hair and wings, a 6B is applied.

Softer lead pencils, such as HB, are used for the darks in her face and her hair.

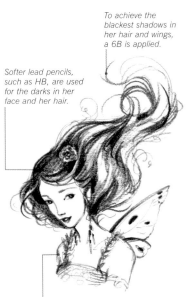

Hard lead pencils such as H and 6H are used to outline the fairy's head and shoulders, sketch in her facial features, and create the small details in her dress and armband.

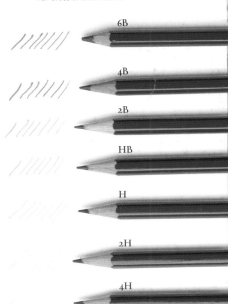

6B

4B

2B

HB

H

2H

4H

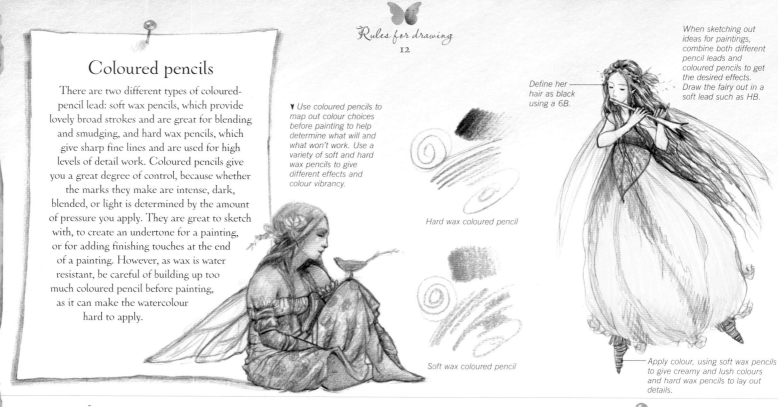

Coloured pencils

There are two different types of coloured-pencil lead: soft wax pencils, which provide lovely broad strokes and are great for blending and smudging, and hard wax pencils, which give sharp fine lines and are used for high levels of detail work. Coloured pencils give you a great degree of control, because whether the marks they make are intense, dark, blended, or light is determined by the amount of pressure you apply. They are great to sketch with, to create an undertone for a painting, or for adding finishing touches at the end of a painting. However, as wax is water resistant, be careful of building up too much coloured pencil before painting, as it can make the watercolour hard to apply.

▼ *Use coloured pencils to map out colour choices before painting to help determine what will and what won't work. Use a variety of soft and hard wax pencils to give different effects and colour vibrancy.*

Hard wax coloured pencil

Soft wax coloured pencil

When sketching out ideas for paintings, combine both different pencil leads and coloured pencils to get the desired effects. Draw the fairy out in a soft lead such as HB.

Define her hair as black using a 6B.

Apply colour, using soft wax pencils to give creamy and lush colours and hard wax pencils to lay out details.

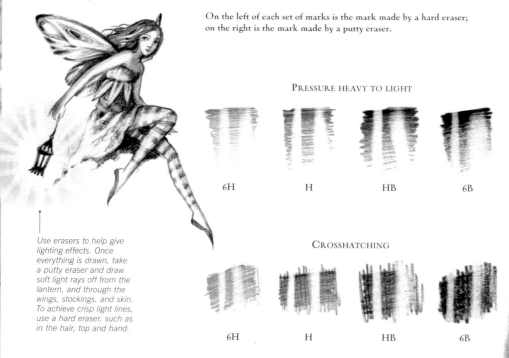

On the left of each set of marks is the mark made by a hard eraser; on the right is the mark made by a putty eraser.

Use erasers to help give lighting effects. Once everything is drawn, take a putty eraser and draw soft light rays off from the lantern, and through the wings, stockings, and skin. To achieve crisp light lines, use a hard eraser, such as in the hair, top and hand.

PRESSURE HEAVY TO LIGHT

| 6H | H | HB | 6B |

CROSSHATCHING

| 6H | H | HB | 6B |

Erasers

There are two types of eraser that you should always have at hand: a putty eraser, which is mouldable and doesn't tear away at the paper when erasing or leave much debris on the paper to wipe off, and a hard eraser, found either in a block or in retractable form. The retractable form is handy, as it can get into small spaces and erase precisely where you want it. A putty eraser doesn't pick up as much graphite as a plastic eraser, so the lead grade and the amount of pressure you draw with will determine how much you can lift up. The softer you draw, the easier it will be to erase. A hard eraser will pick up most of the graphite regardless, but it can abrade your paper if used too strongly.

Sketchbooks and papers

Many drawing papers and sketchbooks provide a smooth or semi-smooth drawing surface. Their colours include brown, blue, grey, cream, ivory and bright white. Sketchbooks and pads are available with glued, wire-spiral, and book-style bindings. Most paper choices come down to personal preference and what is the most enjoyable to work on.

White landscape format.

Spiral-bound sketch pads have a slight tooth to their papers, allowing more smudging and blending in drawing. The pads come in many standard sizes and the paper tones all tend to be white or bright white.

Moleskine sketchbooks provide long-lasting binding and ultra-smooth drawing surfaces that lend themselves to fine pencil and ink drawing. They come in many different sizes and formats, and have pockets inside the cover in which to stash references or clippings. Moleskines have either a cream or white paper tone.

Cream portrait format.

Other tools you may want to consider include templates to achieve precise circles and shapes, a ruler or straight edge and a drafting brush. A drafting brush comes in handy for brushing off any eraser debris instead of using your hands or getting dizzy from blowing it off your paper. A pencil sharpener is also a tool you'll want to keep around.

A Bristol paper or illustration board will give an ultra-smooth surface for extra-fine drawing, inking and marker work.

Fine drawing paper has a slight tooth or texture to it to help grab the graphite, allow for smudging and help with blending techniques.

Pastel and charcoal papers, or toned papers, have a deeper texture to allow greater blending. The tools used can be built up on these papers because the texture holds onto it like a magnet.

Finding your muse

When creating extraordinary beings like fairies, it is important to find things that move you emotionally. An inspiration board acts as a collage, bringing all of these wonderful things together to act as your muse. Whenever you're not sure of what to draw or are stumped for ideas, you can turn to your board. When working, you want the board to be there when you lift your eyes or turn your head, so keep it near you and in your workspace. It doesn't need to be a specific size or even organised. If you keep the layout flexible you can adapt it to your needs – whether those are a specific project or to suit the size of your space. You can have any number of inspiration boards; they can be the inside of a sketchbook or cover a whole bedroom wall. Whenever you see something that you emotionally connect with, and which inspires you, pick it up and pin it to your board. The board should grow continuously.

RULE

1

Collect what motivates & inspires you

You can use any kind of corkboard or wooden board to start. It should be at least 28 x 43cm (11 x 17in) so that you have room to display plenty of inspirational items. You will need a box of drawing pins, preferably ones that you can easily take off and put back in, as you may want to move your pieces often, or place them on your drawing table. Search through magazines, calendars, books, the Internet and even outside for items you can add to your board. Photocopy what you can't tear out. Arrange them so you can see what motivated you to grab the piece in the first place. It's okay if they overlap.

▲ If you will need to move your board, make it from something that can travel with you such as a display file. Place it where you need it most, such as by your art supplies, so you will see it when you reach for them.

▲ Search and use three-dimensional objects including dried and silk flowers, leaves, twigs, feathers, shells and seasonal items for your inspiration boards.

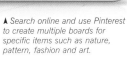

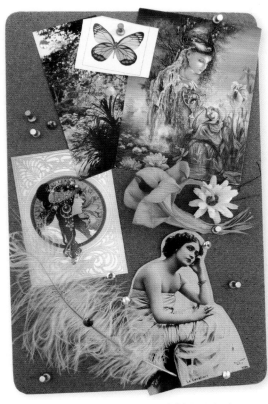

▲ Search online and use Pinterest to create multiple boards for specific items such as nature, pattern, fashion and art.

▲ Bring together items from your main board to a smaller one to create a theme for a project. Use photo references, three-dimensional items, small things you have found, other artists' work and colour palettes.

RULE

2

An inspiration board is always a work in progress

Your board never stops growing. Your taste in colour, design, art and even subject matter changes with you as the years go by. Use pins to attach inspiration so you have the flexibility to move images around and take them off when they no longer inspire you. When it's time to sort through your board and remove what doesn't inspire you, save what you take down to make a scrapbook of past musings, or recycle what you can. Change your board for a specific project by taking off what you don't need and adding only items based on the theme you're working on. Be sure to re-pin your board after the project is finished.

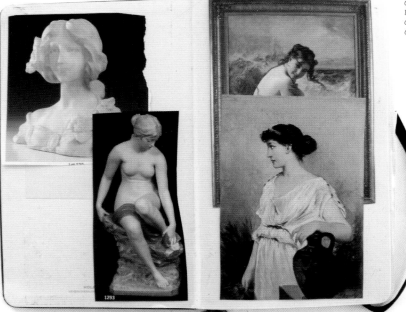

◄ Use your sketchbooks as inspiration boards so you always have a place to store images you find that move you. Simply tape your inspirations directly into the book. Use tape instead of glue so you can move and change it if you need to.

Expressing movement

To make your figures feel alive, you must learn how to draw movement. Gesture drawing is an age-old practice used by the masters long ago to discover how to find rhythm, balance, and expression. It is an essential daily practice and an exercise that can be done using mannequins, reference books, or your imagination. Get into the habit of doing regular gesture drawings before you begin a project, as a break from work or while you're out and about people-watching. Keep a small sketchbook and pen with you in free moments to fill with gesture drawing. If you become disciplined in gesture drawing and conveying movement, you will improve your drawing skills greatly!

RULE

3

Study with speed

Keep your gesture drawing quick – complete one in less than a minute or two. Time yourself with a stopwatch and challenge yourself to create fifteen-second sketches! Fill up a page in your sketchbook with multiple studies using general shapes, such as ovals, circles and simple lines. Don't worry about the details as these will take your focus away from the movement.

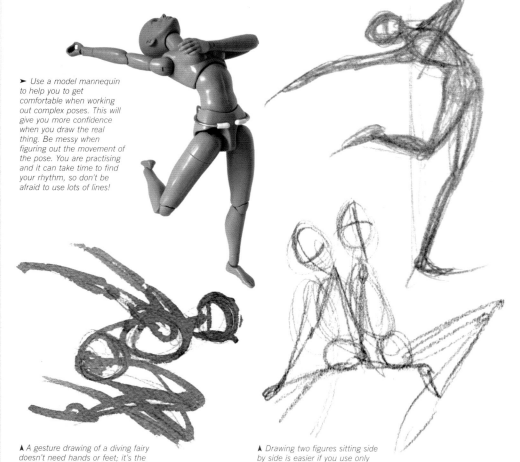

◄ *Drawing a figure hiding or holding something behind the back may require you to overlap shapes when drawing the arms. Not only will this accurately position the arms, it will also keep your speed faster.*

➤ *Use a model mannequin to help you to get comfortable when working out complex poses. This will give you more confidence when you draw the real thing. Be messy when figuring out the movement of the pose. You are practising and it can take time to find your rhythm, so don't be afraid to use lots of lines!*

▲ *A gesture drawing of a diving fairy doesn't need hands or feet; it's the action that matters. Don't get caught up worrying about the little things.*

▲ *Drawing two figures sitting side by side is easier if you use only circles and straight lines – similar to the way stick figures are drawn. The complexity of showing two together means simple is better.*

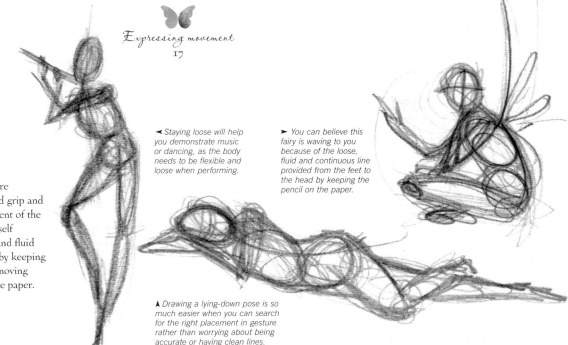

RULE 4

Stay loose when drawing

Staying loose is the key to giving your figure expression. Hold your pencil with a relaxed grip and a relaxed arm. Focus and 'feel' the movement of the pose you're working from, imagining yourself in that pose, and then create quick, loose and fluid strokes. Find a rhythm in your movement by keeping the pencil on the paper most of the time, moving from one spot to the other while still on the paper.

◄ *Staying loose will help you demonstrate music or dancing, as the body needs to be flexible and loose when performing.*

► *You can believe this fairy is waving to you because of the loose, fluid and continuous line provided from the feet to the head by keeping the pencil on the paper.*

▲ *Drawing a lying-down pose is so much easier when you can search for the right placement in gesture rather than worrying about being accurate or having clean lines.*

RULE 5

Define your shape

Describe the three main masses of the figure – the head, rib cage, and pelvis – using shape, size and position. Establish the movement by locating the spine first, which is also called the 'line of action'. Draw the head mass, an oval, then the line of action attached to it. Follow this with the rib cage mass, which is an oval bigger than the head. Next, add the pelvis mass, which is close in size to the size of the head but lays on its side. These three masses swivel and show the main force of movement. Finish the pose by adding arms and legs, which are more teardrop- or cylinder-shaped.

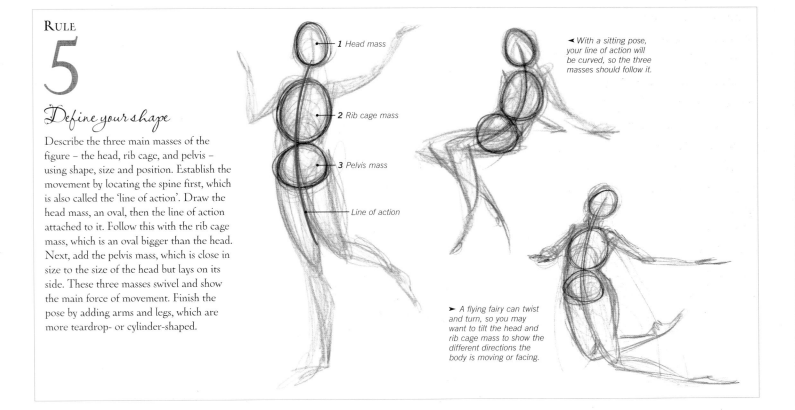

1 Head mass

2 Rib cage mass

3 Pelvis mass

Line of action

◄ *With a sitting pose, your line of action will be curved, so the three masses should follow it.*

► *A flying fairy can twist and turn, so you may want to tilt the head and rib cage mass to show the different directions the body is moving or facing.*

Fairy proportions

To be believable, a fairy's body needs to be drawn to the correct proportions. This will enable you to find the relationship between each body part: where it goes and the size it needs to be. It can also help to tell the viewer the age, height or even the type of fairy. For example, a pixie would be smaller than a woodland fairy. Each fairy has a different body proportion from the next, but for beginners there is a standard chart that uses the head as the basic unit of measurement. Many artists use this chart to create human figures, then adjust it when they need to convey heroic, elegant or fantastical characters. After much practice these proportions become natural, and your eye will learn how to see the correct placement of each body part.

RULE 6

The head is your ruler

Using a figure's head is a popular way to keep proportions in check when drawing a fairy. Drawing heads, which should be oval-shaped, equal in height and width to each other, and stacked on top of each other, becomes a way to measure out the body. This will help make sure each part is in the right place. The measurements change as the body becomes taller or shorter. Use the standard proportion chart as a guide when developing different fairy body types.

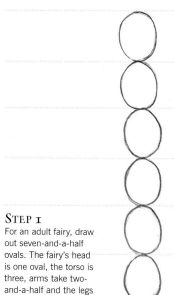

STEP 1
For an adult fairy, draw out seven-and-a-half ovals. The fairy's head is one oval, the torso is three, arms take two-and-a-half and the legs measure three-and-a-half.

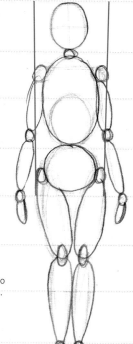

STEP 2
Start to draw out the basic shapes of your figure. Keep the ovals separate from the figure drawing so you do not become confused with too many overlapping shapes.

RULE

7

Standard proportions

To find the right size for your fairy, use
this standard proportion chart to find
where the body parts should be placed,
depending on the number of heads.

4 Heads
Baby

5 Heads
Young child

6 Heads
Child

7 Heads
Adolescent youth, teenager

8 Heads
Tall adult

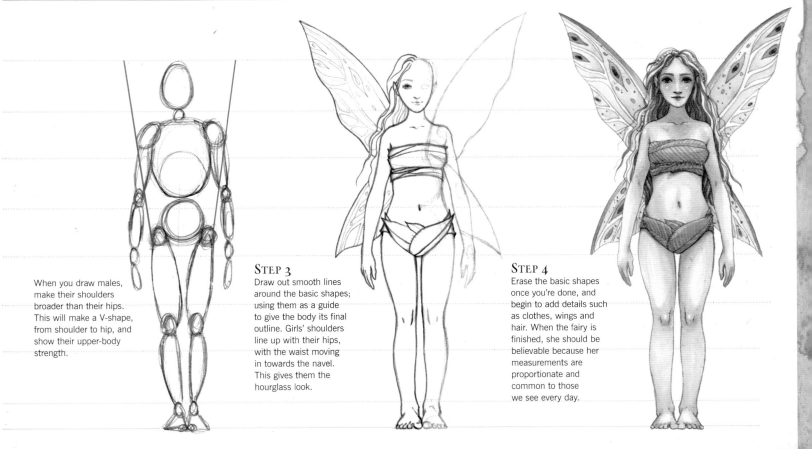

When you draw males,
make their shoulders
broader than their hips.
This will make a V-shape,
from shoulder to hip, and
show their upper-body
strength.

STEP 3
Draw out smooth lines
around the basic shapes;
using them as a guide
to give the body its final
outline. Girls' shoulders
line up with their hips,
with the waist moving
in towards the navel.
This gives them the
hourglass look.

STEP 4
Erase the basic shapes
once you're done, and
begin to add details such
as clothes, wings and
hair. When the fairy is
finished, she should be
believable because her
measurements are
proportionate and
common to those
we see every day.

Fairy anatomy

Anatomy is the understanding of muscles and bones, how they move, and their placement within the proportions of the body. Learning some basic anatomy will help you better understand your model or reference when drawing from it, allow you to draw positions without the need of reference and ultimately make your fairies more lifelike.

RULE

8

Learn basic muscle groups

As you start to understand these muscle groups, you will find it easier and quicker to draw in the final outlines of your fairy. Use the shapes you know, such as circles and ovals, to locate and sketch in the muscles. Once you have placed all of the main muscles on to your figure, create smooth outlines transitioning from the large ovals, for example the thigh, to the smaller circles, for example the knee. To transition, follow the thigh oval down and bridge it to the knee. Then transition out again, bridging the knee to the calf oval. This takes practice, so follow the images and muscles you see here, and take your time.

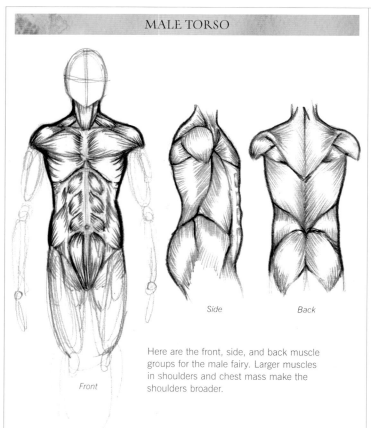

MALE TORSO

Side *Back* *Front*

Here are the front, side, and back muscle groups for the male fairy. Larger muscles in shoulders and chest mass make the shoulders broader.

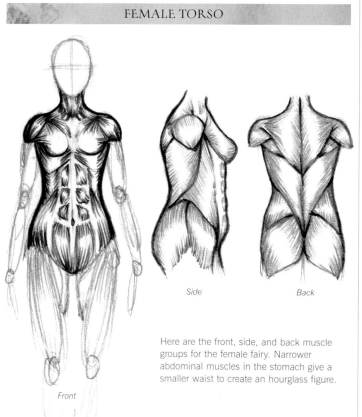

FEMALE TORSO

Side *Back* *Front*

Here are the front, side, and back muscle groups for the female fairy. Narrower abdominal muscles in the stomach give a smaller waist to create an hourglass figure.

TORSO

Once you know where the torso muscle groups are, you can find the outline of the figure in different poses.

Reaching up and back

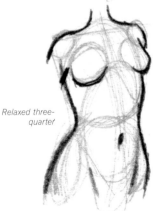

Relaxed three-quarter

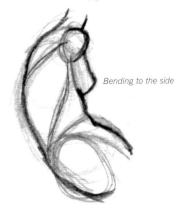

Bending to the side

LEGS

Leg muscle groups are the same for both male and female figures. Use ovals for every muscle, and circles for knees and ankles.

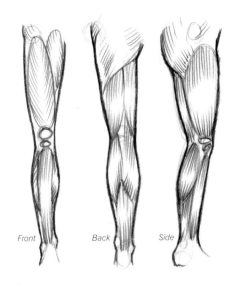

Front　　*Back*　　*Side*

When drawing your outline, follow the largest muscles such as the thigh and calf, and smoothly transition in and out of the narrow spots such as the knee and ankle.

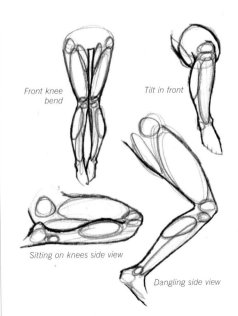

Front knee bend　　　*Tilt in front*

Sitting on knees side view

Dangling side view

ARMS

Arm muscle groups are smaller for female figures and larger for male figures. Change the main muscles, shoulder, bicep, and forearm, accordingly.

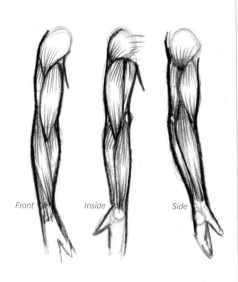

Front　　*Inside*　　*Side*

Bend the arms at the elbow and wrist joints. Lift the arms from the shoulder joint.

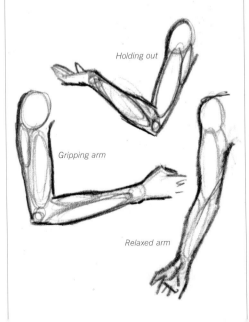

Holding out

Gripping arm

Relaxed arm

HANDS

When drawing hands, use simple shapes and lines for the bones, build on more shapes for muscles, then create your final outline, which is the skin.

Experiment with drawing different positions by using your own hand as a reference.

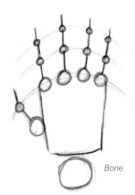

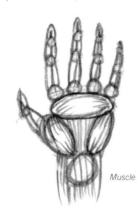

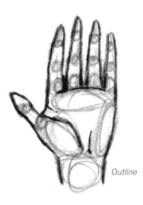

Bone

Muscle

Outline

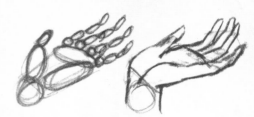

Palm up

Use the bone structure to find the hand pose before laying in muscles or outlining the skin.

Relaxed hand

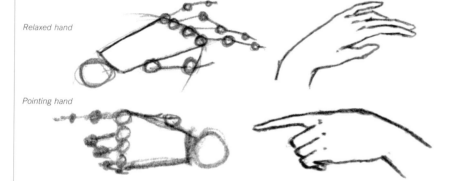

Pointing hand

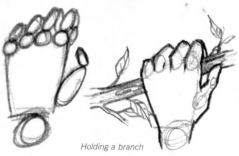

Holding a branch

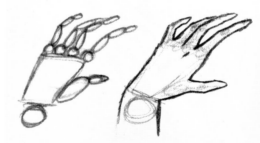

Casual hand

Once you have mastered the basics, you can elongate your fairy's hands to show their otherworldly form.

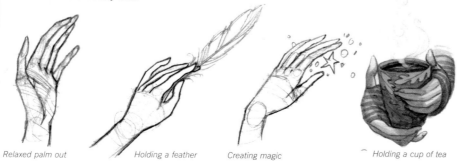

Relaxed palm out *Holding a feather* *Creating magic* *Holding a cup of tea*

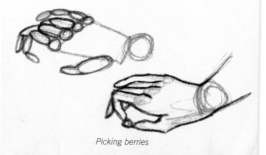

Picking berries

FEET

Locate the heel of the foot with a circle, ball of the foot with an oval, and connect with a triangle to define the outline. Recognise where the bones and muscles are in relation to how the foot is positioned.

By breaking the foot down into simple shapes, it is possible to draw feet from more challenging angles.

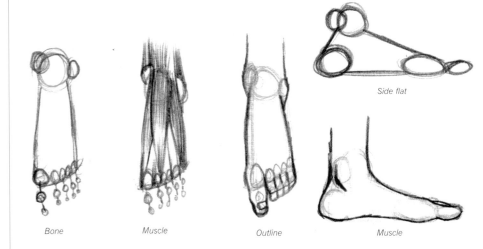

Side flat

Bone

Muscle

Outline

Muscle

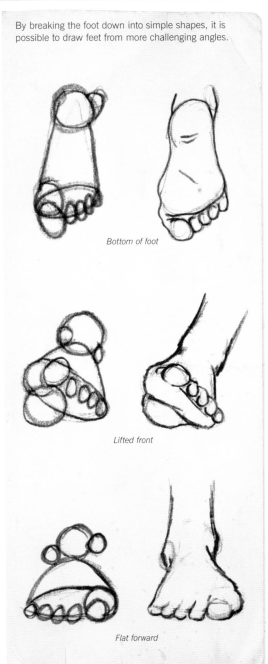

Bottom of foot

Lifted front

Flat forward

If you stretch and distort the proportions of your fairy's body (see page 19), then everything else should follow, including hands and feet.

Dangling toes pointed in

Sitting feet together

Playful walking feet

Standard standing boy

Face structure

Although every fairy will have different facial features – the layout of a noble royal fairy with soft and slender eyes and a long regal nose will be very different from that of a pixie, who may have larger eyes full of wonder and a smaller button nose – to start with you will need to know the basic layout and placement of the eyes, nose, mouth and ears. When learning the proportions of the face, start with a light-coloured pencil so that when you draw the details with graphite pencil, you'll see your final lines more readily.

RULE

9

Use the eye as a form of measurement

Just as the body is measured using heads, the face is measured using the eye. First, find the correct location of the eyes using the methods shown here, and place them. From there you will use them to find where all of the other features go. If you're not sure about the distance of one feature to the next, use an eye as a default. Like the body, the facial features can be exaggerated to describe your fairy. Make the nose longer, the eyes wider or the mouth smaller. If it looks too off, it's usually a problem with the eyes. Go back to the default shown here in the examples, and make sure they're at least one eye apart.

DRAWING A FACE FROM THE FRONT

 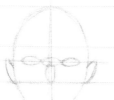 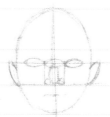 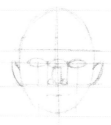 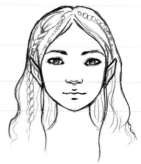

STEP 1
Loosely draw an oval and divide it into four quarters. It's important that each guideline is centred horizontally and vertically.

STEP 2
Start by drawing one eye centred on the horizontal guideline. Now draw one eye on each side of the eye. Draw in the length of the nose by rotating an eye 90 degrees along the vertical guideline. Draw another horizontal guideline across the head oval from the bottom of the nose to create the nose line. Draw the ears between the eye line and the nose line.

STEP 3
The base of the nose is one eye width. To finish the nose, draw two lines down from the sides of the middle eye and place a circle on each side to create the nostrils. Find the mouth line by moving down from the nose one eye height. Draw the mouth line slightly wider than one eye width, and then position the lips.

STEP 4
Draw in the neck using the two outer eyes on the eye line. Find their centre and draw guidelines straight down past the chin. These are your neck lines. Place the eyebrows one eye height above the eye line.

STEP 5
Draw in the chin and face shape, erase all of your guidelines including the middle eye, and add features such as hair, irises and pupils. Draw the hair below the top of the head oval, or your fairy will look bald to the crown of her head.

DRAWING A THREE-QUARTER VIEW OF THE FACE

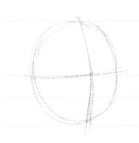
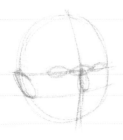
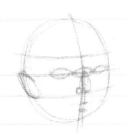
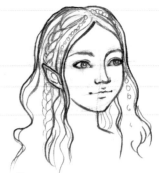

STEP 1
Draw an oval loosely, dividing it into four parts, with a horizontal guideline in the centre, and a vertical guideline bent slightly to the right. This vertical guideline shows the curve of the head.

STEP 2
Draw one eye in the middle and two on each side. Establish the nose by drawing it one eye width up on its end and slightly to the right, so the side rests just off the vertical centre line. Draw the ear on the left side of the head.

STEP 3
Add a circle for the nostril, so that the width of the nose is equal to the middle eye. Lay in the mouth line one eye height apart from the nose line. Draw it slightly wider than the nose and middle eye.

STEP 4
Define the cheek and chin by following the right side curve of the oval and coming to a very soft point at the bottom. Then gradually draw the line back up the left side to the base of the ear. Neck lines align with the centre vertical guideline and the bottom of the ear.

DRAWING A FACE IN PROFILE

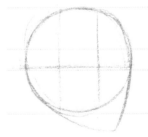
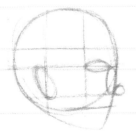
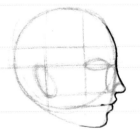
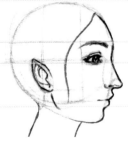
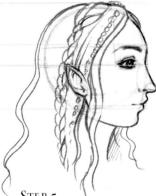

STEP 1
Loosely draw a circle and divide it into six equal parts. Add a chin by drawing straight down on the right side of the circle then gradually curving back up to the first vertical line. The horizontal line should be in the centre between the chin and top of head, creating the eye line.

STEP 2
Draw an eye on the eye line in the right section. Place your nose from the corner of the eye, one eye width down. Add a horizontal line from the bottom of the nose to the left. Place the ear on the left vertical line between the eye and nose line. Sketch in the mouth, from the base of the circle to the side of the head.

STEP 3
Smooth out the profile, starting with the forehead. Follow the curve of the circle and dent in slightly before you reach the eye. Create the arch of the nose down to the tip. Go straight back towards the head and lightly sketch in the lips. Continue following the head shape and draw in your chin.

STEP 4
Place the neck from the right vertical guideline and from the left vertical guideline. Add in the eyebrow, nostril, iris and pupil. The hairline should start to the right of the right vertical guideline at the top of the head.

STEP 5
Erase all of your guidelines and add in the hair. Keep your hairline at the top slightly above the head shape as hair grows up then falls back down.

Designing wings

Wings are as expressive as the fairies themselves, and you should put a lot of thought into the design. Through the use of shape, line and markings, the wings give you insight into the fairy's nature and type.

RULE

10

Use guidelines for accuracy

Choose a set of insect wings that already exist in nature. Draw a square and divide it into four sections (this is similar to drawing a face). From here, adding guidelines will help you map out where important marks, edge patterns, and other design elements go. The guidelines are drawn from one side of the wing to the other, showing you where to draw a curve or mark on the opposite side. Once the basic shape of the wings is drawn, use your imagination to enhance the wings. Draw the guidelines where they are needed, and use a ruler if you need help to see where the edges meet up. Make as many guidelines as you need to find the symmetry between both sides. When finished, erase the guidelines.

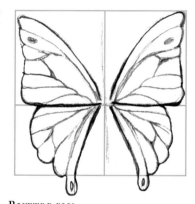

BUTTERFLY

Start with a set of wings you're familiar with, such as these butterfly wings. Draw a box and divide it into quarters.

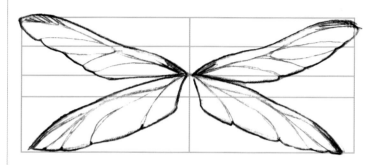

DRAGONFLY

Use dragonfly wings to create a more elaborate and playful design. Use a photograph as reference and add the veins you see from the photo using guidelines. Choose which veins to draw and which ones to leave out, as there is an overwhelming amount to draw.

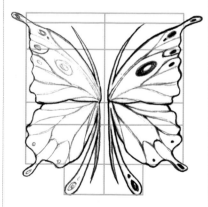

IMAGINATIVE FAIRY WINGS

Break from the traditional butterfly wing and get imaginative. Cut out parts on the sides and add more accents to the ends. Make guidelines to ensure accurate placement of the side design and end accents.

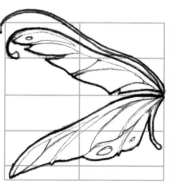

MAGICAL FAIRY WINGS

Draw additional antennae at the top and inside of one wing, and bring in a delicate curve to the tips. Draw a guideline from the bottom of the curve over to the opposite wing to place it. Do the same for the antennae and other additional curves.

RULE
11

Draw through the body

To accurately place the wings, you would need to draw them in through your figure, such as you would in gesture. Guessing their placement could result in uneven or unbalanced wings. Generally, the wings come from the centre of the shoulder blades in the back.

Draw your figure in the pose you want, then lightly draw marks to where your wings will begin and end, which is in the centre of each shoulder blade, drawing in each wing, starting and ending at the mark. Erase the inside lines once the wings are in place.

Draw your fairy in a three-quarters view. Draw the wings, keeping in mind that the body will be covering more than half of the wing placed farthest from you. Draw in the wing so what you see in the end is correct. Once the wing is in place, erase the overlapping wing lines.

Draw your fairy in a profile pose, adding the wings from her shoulder blades. This pose shows the wing's true measurement and brings a strong focus to the design.

RULE
12

Use a wing model to find placement

To find the correct perspective of your wings, cut them out in heavy paper and hold them up as a reference. This way you can cut out whatever shape you want and see it from every direction.

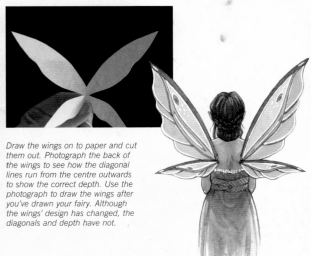

Draw the wings on to paper and cut them out. Photograph the back of the wings to see how the diagonal lines run from the centre outwards to show the correct depth. Use the photograph to draw the wings after you've drawn your fairy. Although the wings' design has changed, the diagonals and depth have not.

Use a paper wing model as reference to draw challenging perspectives by holding it up and drawing straight from it. This will not only help you see the perspectives of the wings in three dimensions, but will help give you all the lines you need to follow in your drawing. Follow the model and draw your fairy's wings. The wings closest to you are very thin because their direction is straight toward you, whereas the set of wings farthest away from you are directing to the right, so you can see their full shape.

Move your wing model around to find interesting perspectives and lines. There are several ways to draw the wings in profile, sometimes showing both sets of wings; other times you will only see one set.

Types of fairy

There are many types of fairy, from the garden fairies from the nineteenth century with butterfly wings to the royal fairies from Shakespeare's *A Midsummer Night's Dream*. A fairy's type reflects where the fairy lives and what the fairy was born to do. Ask yourself what distinguishes your fairy, and what sets her apart from other types. A fairy's type will also give you clues about what they may wear, how they act and move and the colour of their hair and skin.

RULE

13

Find the fairy's identity

To illustrate a fairy's identity, you need to know their environment, the surroundings and the elements with which they interact. Draw your fairy in a pose that shows their talents, place them in clothes made out of their natural environment, show their personality through facial expression and think about how their social life affects who they are. These elements will define who your fairy is and develop their character.

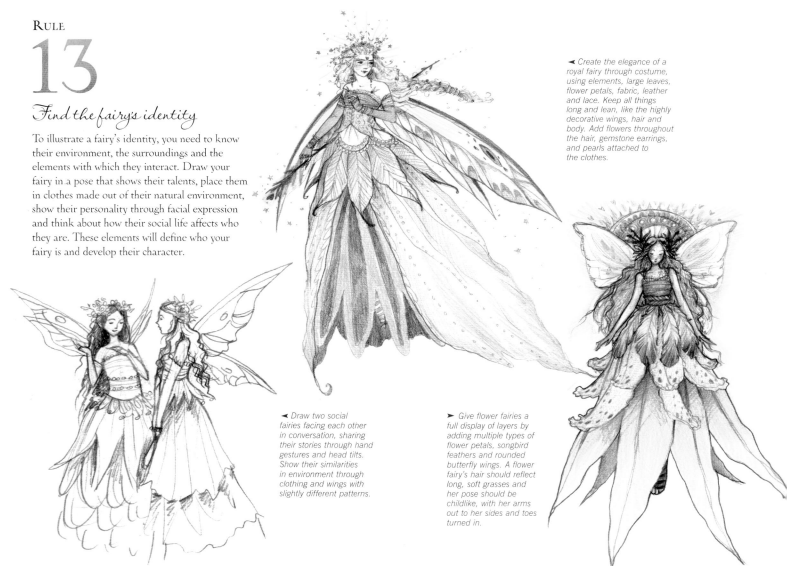

◄ Create the elegance of a royal fairy through costume, using elements, large leaves, flower petals, fabric, leather and lace. Keep all things long and lean, like the highly decorative wings, hair and body. Add flowers throughout the hair, gemstone earrings, and pearls attached to the clothes.

◄ Draw two social fairies facing each other in conversation, sharing their stories through hand gestures and head tilts. Show their similarities in environment through clothing and wings with slightly different patterns.

► Give flower fairies a full display of layers by adding multiple types of flower petals, songbird feathers and rounded butterfly wings. A flower fairy's hair should reflect long, soft grasses and her pose should be childlike, with her arms out to her sides and toes turned in.

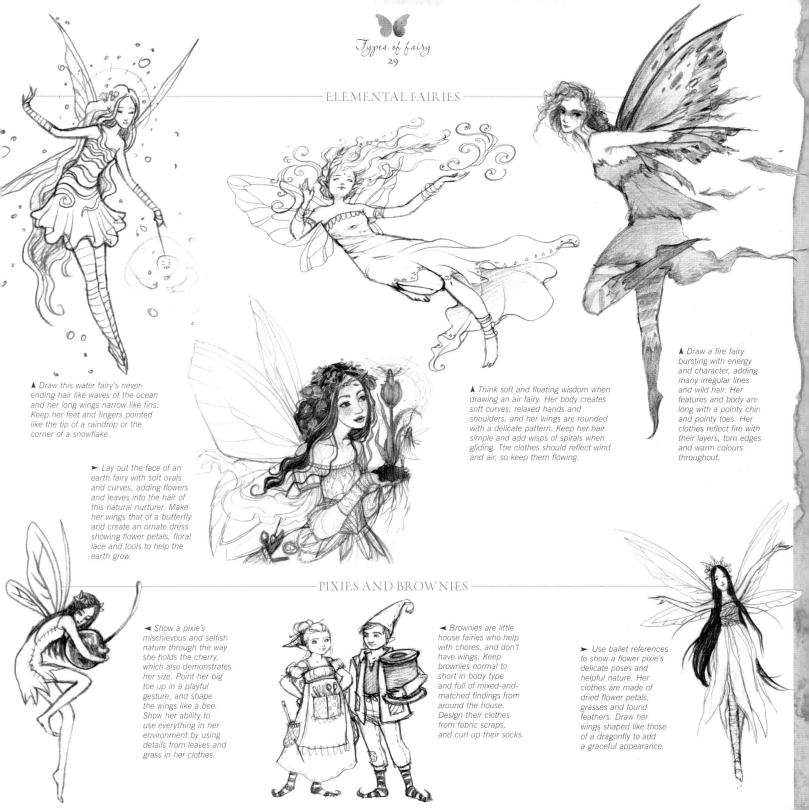

ELEMENTAL FAIRIES

➤ Draw this water fairy's never-ending hair like waves of the ocean and her long wings narrow like fins. Keep her feet and fingers pointed like the tip of a raindrop or the corner of a snowflake.

➤ Lay out the face of an earth fairy with soft ovals and curves, adding flowers and leaves into the hair of this natural nurturer. Make her wings that of a butterfly and create an ornate dress showing flower petals, floral lace and tools to help the earth grow.

➤ Think soft and floating wisdom when drawing an air fairy. Her body creates soft curves, relaxed hands and shoulders, and her wings are rounded with a delicate pattern. Keep her hair simple and add wisps of spirals when gliding. The clothes should reflect wind and air, so keep them flowing.

➤ Draw a fire fairy bursting with energy and character, adding many irregular lines and wild hair. Her features and body are long with a pointy chin and pointy toes. Her clothes reflect fire with their layers, torn edges and warm colours throughout.

PIXIES AND BROWNIES

◄ Show a pixie's mischievous and selfish nature through the way she holds the cherry, which also demonstrates her size. Point her big toe up in a playful gesture, and shape the wings like a bee. Show her ability to use everything in her environment by using details from leaves and grass in her clothes.

◄ Brownies are little house fairies who help with chores, and don't have wings. Keep brownies normal to short in body type and full of mixed-and-matched findings from around the house. Design their clothes from fabric scraps, and curl up their socks.

➤ Use ballet references to show a flower pixie's delicate poses and helpful nature. Her clothes are made of dried flower petals, grasses and found feathers. Draw her wings shaped like those of a dragonfly to add a graceful appearance.

Fairy poses

Fairies engage us through their weightless flying, dreamy perches on rocks or flowers and their spirit of magic. Every pose you give a fairy describes their character and their current mood. Stay loose in the beginning, keep your lines and shapes basic and try to draw lightly. Think of poses you would make if you were being playful on a toadstool or a royal fairy queen knighting a valiant knight, and use the mirror for reference. You can also look at some reference material to inspire a pose for your fairy. At first glance, some poses, such as drawing a dancing fairy where there are overlapping body masses, may be difficult. Referencing the gesture or anatomy rules will help map out where your shapes should go.

RULE

14

Use body language to convey personality

A fairy's pose says a lot about her personality through her body language. What is the fairy saying to those with whom she's interacting or saying to you? Get into character as you draw your fairy's pose. This is how you relate to others, so this could be how others relate to your fairy. How would you stand if you were shy? What would your face and body do if you were excited? What pose would you choose if you were flying among the stars?

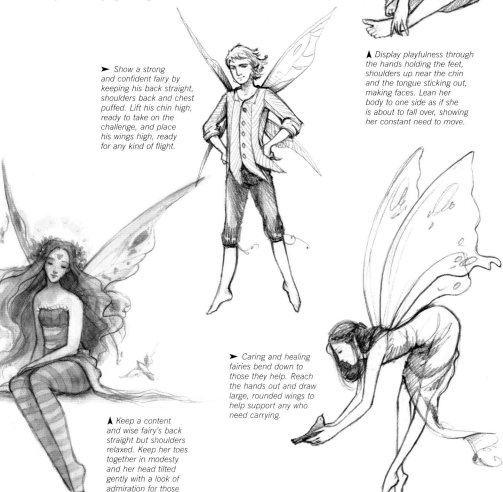

➤ Show a strong and confident fairy by keeping his back straight, shoulders back and chest puffed. Lift his chin high, ready to take on the challenge, and place his wings high, ready for any kind of flight.

▲ Display playfulness through the hands holding the feet, shoulders up near the chin and the tongue sticking out, making faces. Lean her body to one side as if she is about to fall over, showing her constant need to move.

▲ Keep a content and wise fairy's back straight but shoulders relaxed. Keep her toes together in modesty and her head tilted gently with a look of admiration for those around her.

➤ Caring and healing fairies bend down to those they help. Reach the hands out and draw large, rounded wings to help support any who need carrying.

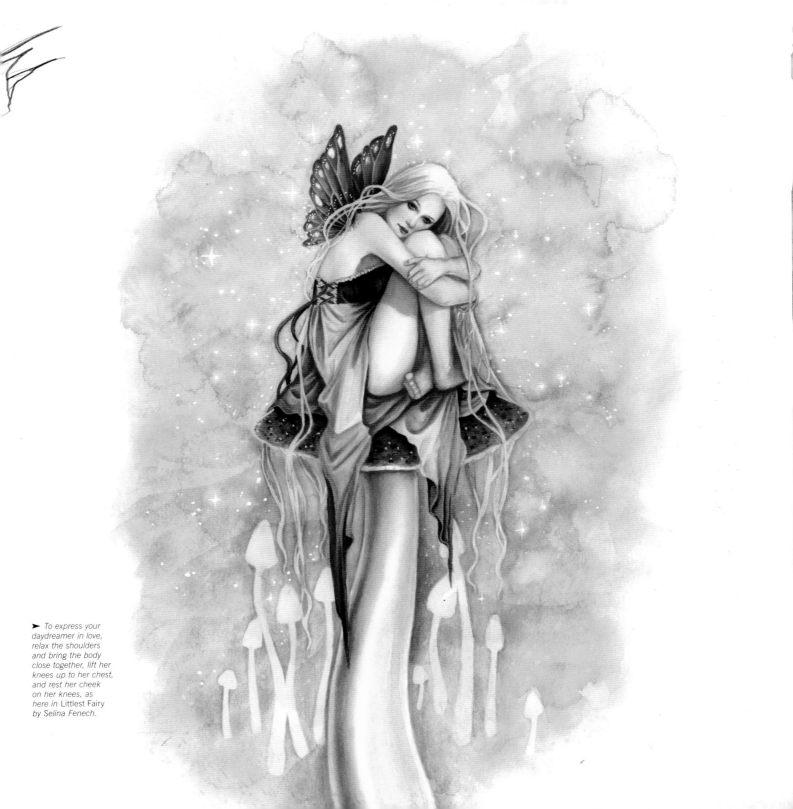

➤ *To express your daydreamer in love, relax the shoulders and bring the body close together, lift her knees up to her chest, and rest her cheek on her knees, as here in* Littlest Fairy *by Selina Fenech.*

RULE

15

Twist and balance figures

Twisting and bending the figure will create very engaging and unique movement in your fairy. To create these poses, bend the spine line then overlap the three main body masses: head, rib cage and hips. You may have to problem-solve the reality of the body's abilities, so research anatomy to make sure the body can bend in the way you have chosen. You will also need to show a strong balance and centre of gravity when drawing such dramatic poses by lining up the nape of the neck to the ball of the foot with a straight line. This will prove your fairy is stable in the position she is holding, demonstrating control and precision.

◄ Draw a line from the nape of her neck down to her toes to check the line of balance needed to hold her up. Check to make sure all of her weight is up on the foot at the bottom of the line. Draw her arms out to the sides, keeping her balanced as if she were walking a tightrope.

▲ Create a dramatic pose by overlapping the main masses, which will then show a sense of depth. Each mass should face a different direction to add more twist. Her chin, which lines up with the nape of her neck, should align with the ball of her foot, creating balance.

◄ Twist the hips and legs left while keeping the rib cage and head right, showing the pulling or carrying of an object, as with this fairy with a dandelion seed.

LET DANCE INSPIRE YOU

Sometimes coming up with a fresh pose can be challenging, so look at dancers and their beautiful movements because they may spark something very special. Dancers can provide creative poses for moments of worship, performing their magic, or even dancing in a fairy circle. Dance poses are so strong that they can show a fairy's personality, movement of physics and graceful balance. Look at ballet photography, watch belly dancers at a fair or watch a video on African tribal ceremonies. These references will show you the poses and celebration found in all dance – something fairies love to do!

➤ A belly-dancing pose creates wonderful angles and twists to use for action poses. Draw her shielding her face, holding something up, or dancing in celebration.

◄ The graceful balance needed in skating or landing can be found in a ballet pose. Ballet also provides wonderful flying poses because of the delicate lines the dancers make.

RULE

16

Study the physics of movement

Fairies fly through trees, land on flowers and hop from leaf to leaf, so their bodies, clothes, hair, and wings are always moving in multiple directions. Laws of physics require if your fairy is moving to the left, everything will move to the right; if she is landing on a flower, then everything moves up. The body will also change, depending on the physics of movement. If you want her to take off from a branch, she would bend her legs to push her body up, or if you want her to fly backwards, her feet may have to be in front of her to stay balanced.

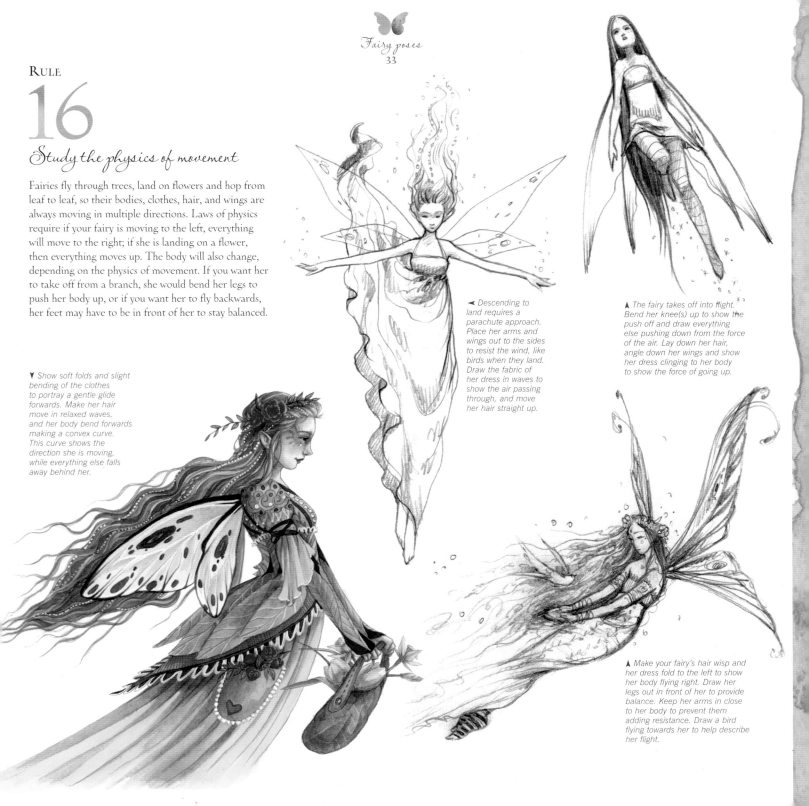

▼ Show soft folds and slight bending of the clothes to portray a gentle glide forwards. Make her hair move in relaxed waves, and her body bend forwards making a convex curve. This curve shows the direction she is moving, while everything else falls away behind her.

◄ Descending to land requires a parachute approach. Place her arms and wings out to the sides to resist the wind, like birds when they land. Draw the fabric of her dress in waves to show the air passing through, and move her hair straight up.

▲ The fairy takes off into flight. Bend her knee(s) up to show the push off and draw everything else pushing down from the force of the air. Lay down her hair, angle down her wings and show her dress clinging to her body to show the force of going up.

▲ Make your fairy's hair wisp and her dress fold to the left to show her body flying right. Draw her legs out in front of her to provide balance. Keep her arms in close to her body to prevent them adding resistance. Draw a bird flying towards her to help describe her flight.

RULE
17

Use reference to teach you what you don't know

There are times when no matter how much you study the figure, you'll run into a pose you need and don't know how to draw. The perspective is too advanced or you don't remember how it should be drawn. Your reference can provide insight into these problems. Look and draw guidelines as well as shapes on your reference to learn how to draw a fish, or the pose of a wolf howling. Working from reference will train your hand and your mind how to draw unfamiliar objects.

◄ *Create collage sheets on the computer using images you find online or scan in from books so you have multiple references of the same subject in one place. Make as many sheets as you need.*

▼ *Find your guidelines and shapes first on the reference itself, then draw it out in gesture using the same shapes and guidelines. This way you'll understand how to build the figure in that pose next time.*

Working from reference

A reference is what we look at to learn how to draw or paint something. Reference comes from magazines, online searches, home photos, a mannequin, copies from a book or anything else photographic or real that sits in front of you from which you can work. It is accurate, real, existing and not drawn, painted or made up. You keep your reference findings and materials organised by themes in folders or pasted in sketchbooks that can travel with you.

You look to reference to find poses, costumes and accessories for your fairies. For example, find a royal fairy's dress, or maybe some flowers for the fairy's hair, from a wedding magazine. Using reference will build your skills in drawing because you are essentially drawing from still life.

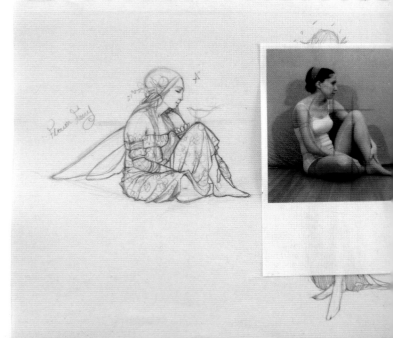

◄ *Organise your files in a small filing box that can be stored easily in small spaces. You don't need many folders to start. Place it near your drawing table for easy access. Label each folder with a category. Start with subjects that you find yourself needing most often. For fairies, start with butterfly wings, flowers, costumes, women and girl figures and trees.*

RULE

18

Keep your references organised

When you have a great idea and need a reference, it can bog you down if you can't find it right away. Keep your references organised by using categories. Fill them up as you search. It may take a few months or projects to build them, but you'll have plenty quickly. Your references can be organised using a filing system, by sketchbooks, three-ring binders or on your computer.

► *A sketchbook is a great place to store and use your reference, especially when designing ideas or characters for larger projects. Tape your reference on one side, and draw on the other side. Use tape so in the future you can reuse the reference elsewhere.*

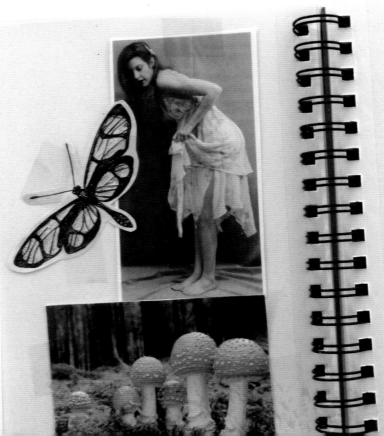

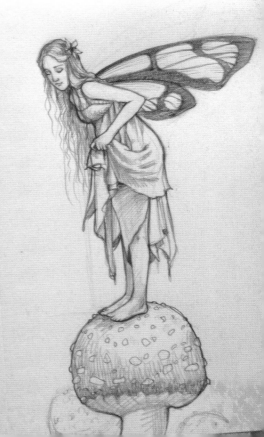

Using reference

Collecting reference material and having a body of imagery to go to is exciting, but how should you go about incorporating it into your work? Unless it is copyright free, you've asked permission to use it, or you took the photograph yourself, then you cannot just copy and paste what you found. The point of using reference material is to help guide you through your drawing, map it out, and get a sense of the whole image by finding pieces and putting them together. You need to make your drawings your own by changing the perspective, colour, pattern, and even some of the structure of your reference material.

▲ **STEP 1**
Sketch in the main shapes of the figure on your reference material, using circles, ovals and lines to locate the head, chest and pelvis masses. Next, find the shoulder, elbow and other joints. Drawing these guidelines in first will help you understand the pose more effectively. Then draw in the lines of the pose – the tilt of the head and shoulders, the position of the facial features, and so on.

RULE

19

Do not directly copy your reference material

Your reference material should help you discover shapes, textures, patterns and poses – but nothing more. Use it to help you piece together a story for your fairy. Start with a pose that inspires you, along with items you would like to add somehow. Think about the fairy's wing type, the environment she lives in, and things she may be wearing or holding. Use a photograph of butterfly wings, but change the pattern; refer to a photo of a flower, but draw from it loosely rather than copying it petal for petal; instead of arranging leaves in exactly the same way as in your reference, just follow their general shape and arrange them in a design of your own.

Do not start with more than 10 reference pieces, as too many will keep you from using your imagination and allowing the art to grow on its own. Use your reference as a springboard and allow yourself the freedom to let the story grow from there.

Establish the lines of the pose...
First, decide which elements of the reference poses you are going to keep in your drawing: in this example, the tilt of the head and shoulders, along with the way the chin rests on the hand, were taken from one reference photo, while the inward-turned toes were taken from another.

... then make it your own
Once you have created your pose, start to change things to make this fairy your own. You used the reference only for the pose, not for the clothing or the hairstyle, and perhaps not even for the facial features. Begin to define your fairy's personality by adding new elements not found in your reference.

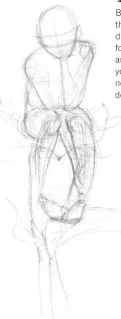

◄ **STEP 2**
Begin to sketch out the pose on your drawing paper, following the shapes and lines you drew on your references. Do not focus on any details yet.

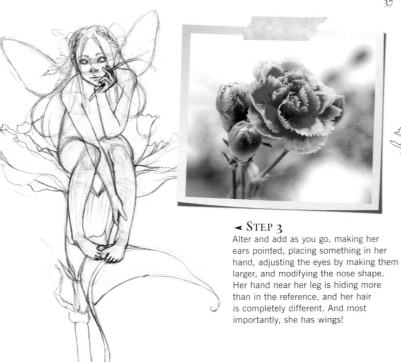

◄ STEP 3
Alter and add as you go, making her ears pointed, placing something in her hand, adjusting the eyes by making them larger, and modifying the nose shape. Her hand near her leg is hiding more than in the reference, and her hair is completely different. And most importantly, she has wings!

◄ STEP 4
Add in clothing, changing the capri pants for striped leggings and the shirt for a dress. Alter the pattern on the butterfly wings by reducing the number of dots and changing the wing shape. Use the carnation flower as a reference for the fairy's chair – but instead of copying it exactly, introduce some invented details.

▲ STEP 5
Use the poppy reference to draw embellishments in the fairy's hair. Don't follow them exactly – instead, study their shapes and then try to draw them without looking back at your reference. This way, you are taking in the information you need to draw poppies but not copying every line, creating your own from memory.

➤ Changing the colours chosen, the light source and the environment will help in making your fairy your own and leave the reference a tool, not what defines your piece.

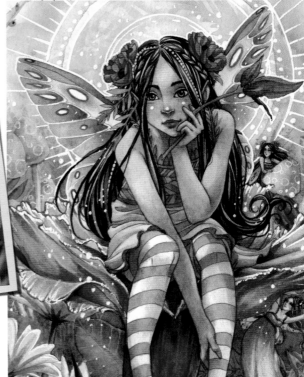

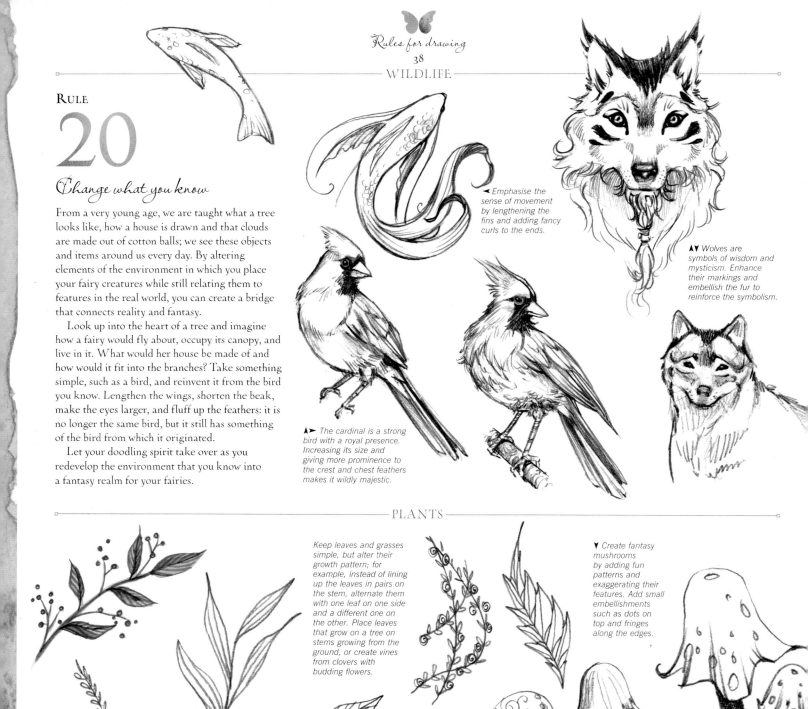

RULE

20

Change what you know

From a very young age, we are taught what a tree looks like, how a house is drawn and that clouds are made out of cotton balls; we see these objects and items around us every day. By altering elements of the environment in which you place your fairy creatures while still relating them to features in the real world, you can create a bridge that connects reality and fantasy.

Look up into the heart of a tree and imagine how a fairy would fly about, occupy its canopy, and live in it. What would her house be made of and how would it fit into the branches? Take something simple, such as a bird, and reinvent it from the bird you know. Lengthen the wings, shorten the beak, make the eyes larger, and fluff up the feathers: it is no longer the same bird, but it still has something of the bird from which it originated.

Let your doodling spirit take over as you redevelop the environment that you know into a fantasy realm for your fairies.

◄ *Emphasise the sense of movement by lengthening the fins and adding fancy curls to the ends.*

▲▼ *Wolves are symbols of wisdom and mysticism. Enhance their markings and embellish the fur to reinforce the symbolism.*

▲► *The cardinal is a strong bird with a royal presence. Increasing its size and giving more prominence to the crest and chest feathers makes it wildly majestic.*

PLANTS

Keep leaves and grasses simple, but alter their growth pattern; for example, instead of lining up the leaves in pairs on the stem, alternate them with one leaf on one side and a different one on the other. Place leaves that grow on a tree on stems growing from the ground, or create vines from clovers with budding flowers.

▼ *Create fantasy mushrooms by adding fun patterns and exaggerating their features. Add small embellishments such as dots on top and fringes along the edges.*

STRUCTURES

◄ *Repurpose a garden summer house into a gentle fairytale cottage far, far away, adding walls, a chimney and a solid oak door.*

◄ *Create a magical mood by drawing the silhouette of an existing castle with fairy dust shimmering upon it. Rearrange the windows and add a steeple or two.*

▲ *Turn a birdhouse into a fairy's house, combining the basic shape with fantastical decorations.*

TREES

➤ *Build your own tree using standard structure elements, and then add to it. Start with the trunk. Fork the trunk apart into several different arms. Next create fingers off the arms for branches. Draw out the basic outline of the leaves. Only suggest the leaves through texture or pattern. Invent the bark with swirls, ovals and sporadic lines.*

◄ *Search for the face within a tree to find your next character. Use the knots and bark to sculpt out a face and hands. Embellish the bark to fit the face and design of the tree sprite.*

FLOWERS

◄ *Create elaborate daisies out of your original reference by adding more petals in different shapes and sizes. Combine soft petals with sharp, rigid ones to create a spunky daisy.*

▼ *Apply a fabric texture to your flowers and spice them up using squiggly lines to bring the petals to a point instead of the soft, undulating edge that every poppy flower has.*

◄▲ *Begin to doodle flowers on your own using pattern. Start from the centre and work your way out to the petals. Use ovals, diamonds, triangles, teardrops and other layering shapes.*

➤ *Design your own tulip by drawing one from reference, but change the leaves and give them more free flow. Add the spots of a tiger lily and pollen fingers growing out from the top to change the appearance.*

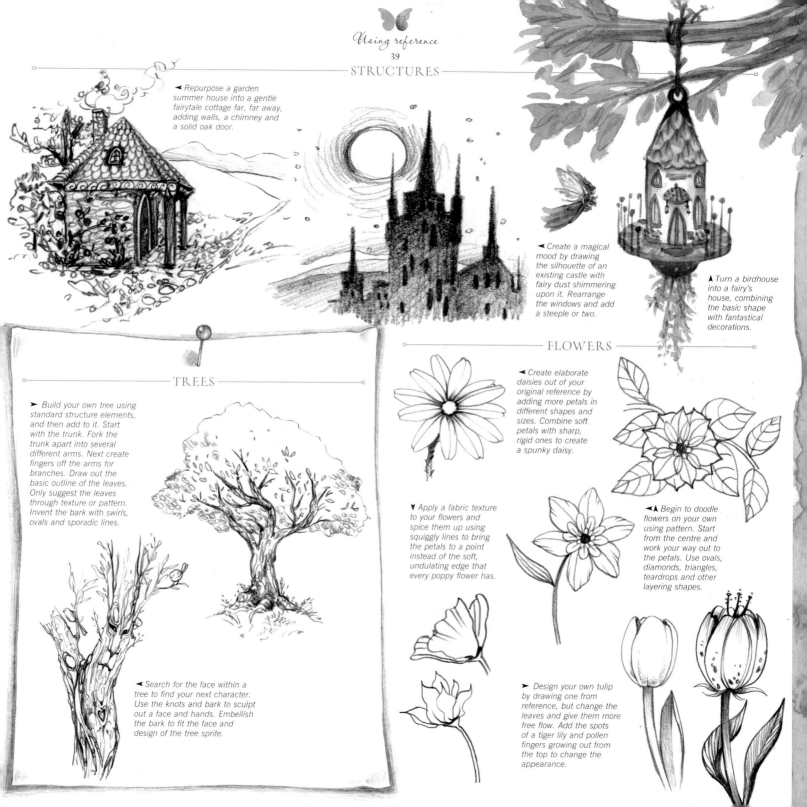

Developing characters

The first step to designing a character is to give them a story.
Think about where the fairy lives and what she does every day.
Is she a princess wearing rich clothing or a cottage garden fairy?
Clothing also changes form and function with the seasons
and weather. Gather reference and inspiration from
historical books, art history and the world around you.
Pick flowers from your garden or take snapshots outdoors
to draw from later.

➤ *Use wrapped and gathered petals to create a garden fairy dress. An inverted blossom makes a wonderful parasol. Poppy petals already have a ruffled edge.*

▲ *Butterfly and moth wings have endless patterns and colours. Use them as patterned motifs on skirts or additions to crowns and jewellery.*

◄ *Draw a forest fairy dressed in variety of leaves, acorns and seed pods. Maple tree seed pods are the inspiration for this fairy's wings.*

RULE

21

Be inspired by nature

Fairies are at home in forests, gardens, streams and lakes.
Make their clothing reflect where they live by drawing materials
that they would find near their homes. Cobwebs, leaves,
seedpods, flower petals, grasses and vines can all become
fabrics for small pixies and decorations for larger fairies.

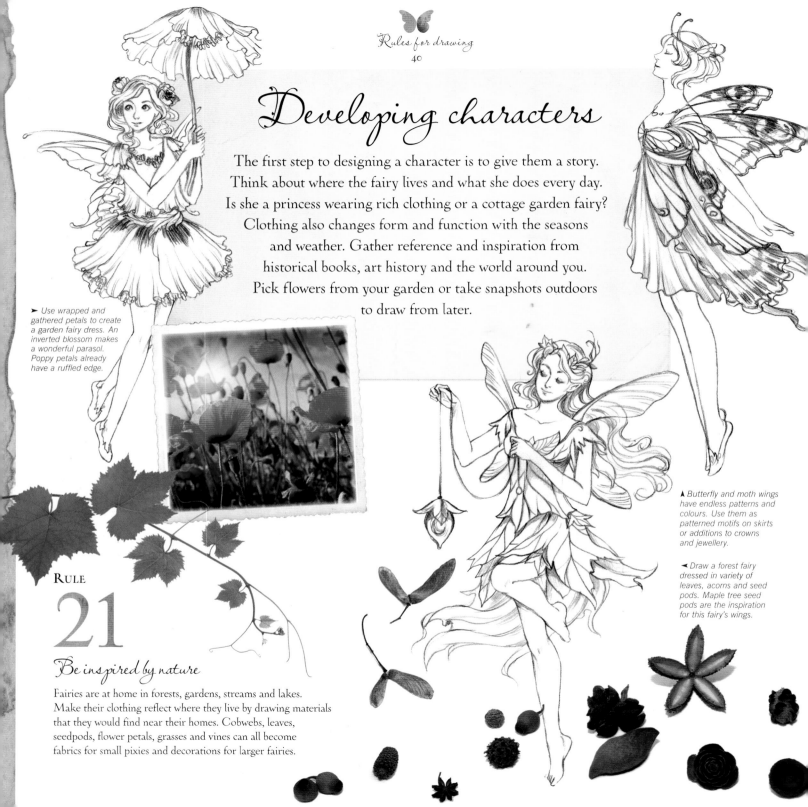

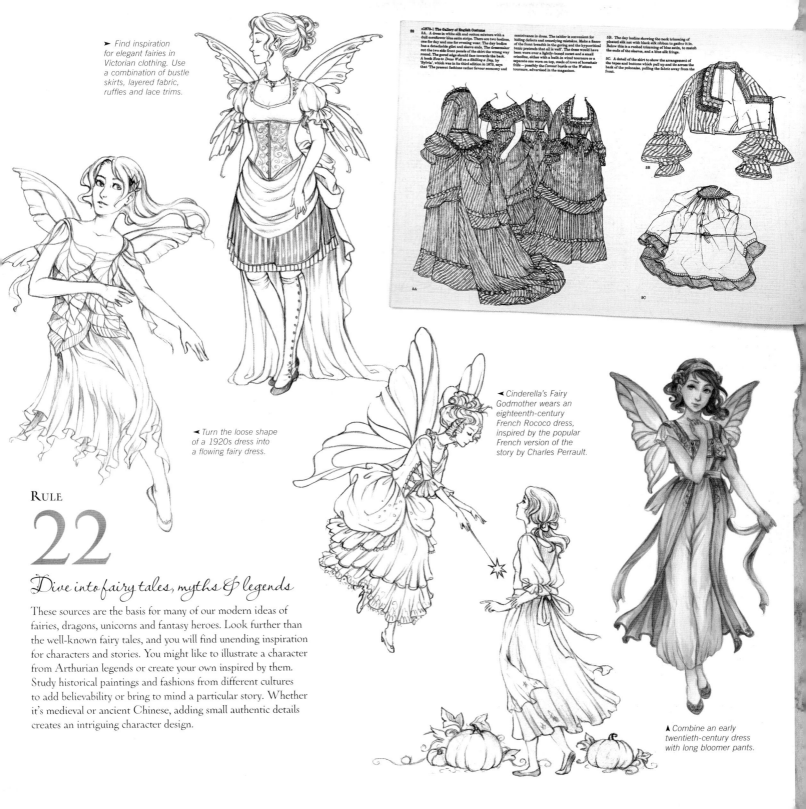

➤ Find inspiration for elegant fairies in Victorian clothing. Use a combination of bustle skirts, layered fabric, ruffles and lace trims.

c1870-1 The Gallery of English Costume

5A. A dress in white silk and cotton mixture with a dull cornflower blue satin stripe. There are two bodices, one for day and one for evening wear. The day bodice has a detachable gilet and sleeve ends. The dressmaker cut two side front panels of the skirts the wrong way round. The gored edge should face towards the back. A book *How to Dress Well on a Shilling a Day*, by 'Sylvia', which was in its third edition in 1875, says that: 'The present fashions rather favour economy and

contrivance in dress. The tablier is convenient for hiding defects and remedying mistakes. Make a fiasco of the front breadth in the goring and the hypocritical tunic pretends that all is well'. The dress would have been worn over a lightly-boned corset and a small crinoline, either with a built-in-wired tournure or a separate one worn on top, made of rows of horsehair frills — possibly the *Coreent* bustle or the *Watteau* tournure, advertised in the magazines.

5B. The day bodice showing the neck trimming of pleated silk net with black silk ribbon to gather it in. Below this is a ruched trimming of blue satin, to match the ends of the sleeves, and a blue silk fringe.

5C. A detail of the skirt to show the arrangement of the tapes and buttons which pull up and tie across the back of the polonaise, pulling the fabric away from the front.

◄ Turn the loose shape of a 1920s dress into a flowing fairy dress.

RULE

22

Dive into fairy tales, myths & legends

These sources are the basis for many of our modern ideas of fairies, dragons, unicorns and fantasy heroes. Look further than the well-known fairy tales, and you will find unending inspiration for characters and stories. You might like to illustrate a character from Arthurian legends or create your own inspired by them. Study historical paintings and fashions from different cultures to add believability or bring to mind a particular story. Whether it's medieval or ancient Chinese, adding small authentic details creates an intriguing character design.

◄ Cinderella's Fairy Godmother wears an eighteenth-century French Rococo dress, inspired by the popular French version of the story by Charles Perrault.

▲ Combine an early twentieth-century dress with long bloomer pants.

Costume

Studying how fabric falls and folds is extremely helpful when drawing fairies in costumes. Think about the fairy's pose, movement, and the type of fabric they are wearing – all these things will affect how you draw the fabric drapery. You can easily make your own examples to draw from by draping a sheet over furniture and arranging the folds.

RULE

23

Understand how fabrics work

Draw silky fabrics with more wrinkles, soft and flowing. Folds fall closer together, and fabrics are often sheer. Light, silky fabrics and flowing, organic forms are perfect for ethereal fairies like air spirits, fairies and angels to wear. Use angular shapes to portray heavy fabrics. The thicker the fabric, the fewer wrinkles it shows. It has a greater tendency to lie flat, and folds will be shallow.

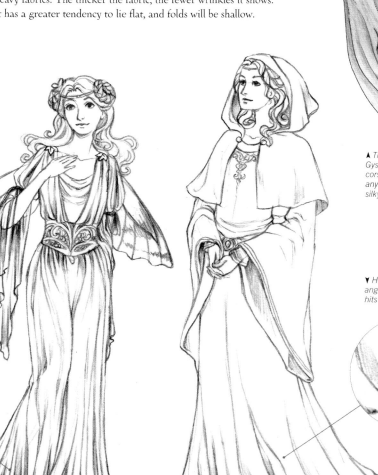

▲ This fairy, by Suzanne Gyseman, wears a stiff, tight corset, which does not show any creases, and a light, silky skirt, which has many.

▼ Heavy fabric forms large angular folds as the fabric hits the ground.

➤ Light fabric forms many narrow folds and rounder forms.

RULE

24

Let gravity guide you

Think about where the form of the body will show through at horizontal planes such as the shoulders, hips or lifted arms and legs. Folds will radiate from these flat areas where the fabric rests. As drapery falls to the ground, the ground breaks up the wrinkles, which fold back on themselves. Lifted arms, bent limbs and clasps and buttons push and pull fabric. When fairies fly through the air, their clothing doesn't need to be bound by gravity: draw lightly floating skirts to show the weightlessness of tiny fairies and magical beings.

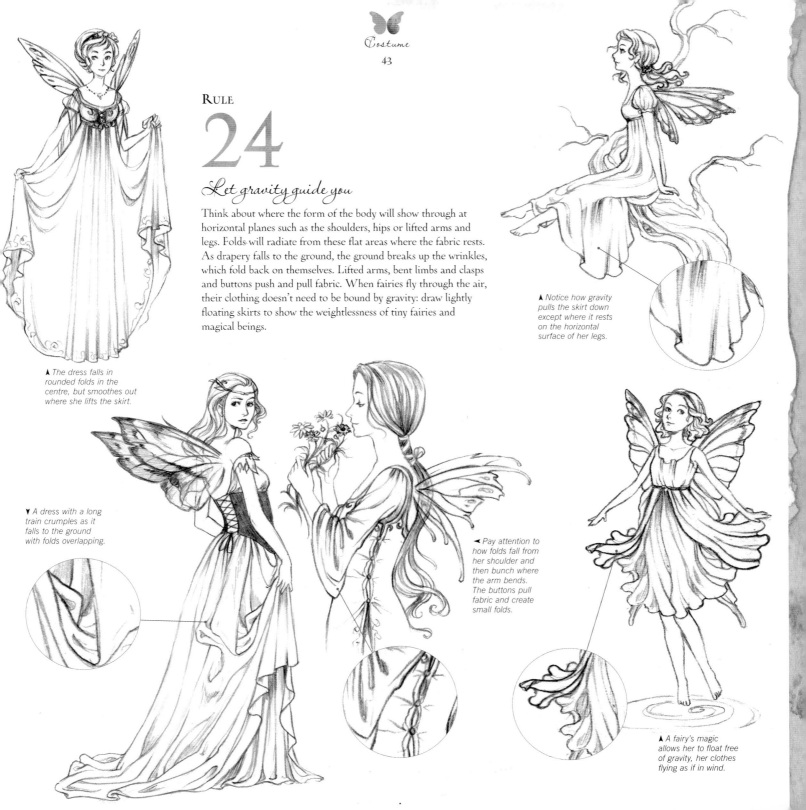

▲ *Notice how gravity pulls the skirt down except where it rests on the horizontal surface of her legs.*

▲ *The dress falls in rounded folds in the centre, but smoothes out where she lifts the skirt.*

▼ *A dress with a long train crumples as it falls to the ground with folds overlapping.*

◄ *Pay attention to how folds fall from her shoulder and then bunch where the arm bends. The buttons pull fabric and create small folds.*

▲ *A fairy's magic allows her to float free of gravity, her clothes flying as if in wind.*

Texture & pattern

To bring the best out of any clothing, object, or environment, you need to incorporate texture and pattern. Texture describes what an object feels like – for instance, the rigid, bumpy texture of bark. Textures are defined primarily through the use of shape and shadows. Patterns can be as simple as polka dots or as complex as geometric shapes on a grid. Every pattern can help say more about your fairy: if she wears lots of flower fabrics, then she might be a flower fairy; if she wears furs, maybe she's from the north. Both texture and pattern are ways of bringing your viewer in to look more closely and connect with the fantasy you are creating.

RULE

25

Use texture & pattern to describe your fairy's world

Without texture, your fairy's clothes, objects and even her environment would look very flat – like pieces of paper. Without pattern, the fabric of her skirt would be drab, with nothing to describe the life and culture in which she lives. But add a leaf pattern and some strings of thread hanging from the ends and you have a story beginning to unfold. Combine texture and pattern as often as you can, perhaps grabbing a texture from an acorn and applying it to an arm cuff or dying fur with a checkered pattern. Fairies are creative and full of inspiration, so experiment with the multitude of possibilities!

GRASS DRESS

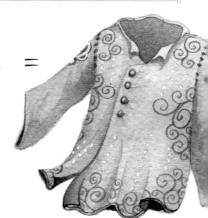

Apply patterns such as twill for the leaves, and other patterns like leaves or vines in other areas. These flow well with a field or forest fairy design.

Grass comes in several different colours, thicknesses and strengths. When many stalks are bundled together, it can provide a hearty texture.

ROYAL TUNIC

Draw out random swirls, one upon the other, to fill the tunic's pattern of interest. Place dots up from the swirl's tips or from other seams or edges. Finish it off with golden buttons.

Use a fabric that is light and has lots of movement. Linen is loosely stitched, allowing air to flow quickly. Other fabrics to use include silk or hemp.

PINECONE BOOTS

 + 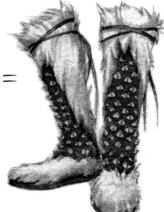 =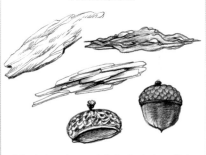

Use pinecones for articles of clothing or objects needing a harder and more protective surface, such as boots or bags. Pinecones also give a lush and detailed pattern on top of their heavy-duty texture.

Create other geometric patterns, similar to pinecones, to add an illusion of strength.

ARMOUR

Using bark and acorn shells for the texture will give much depth to the object by providing heavy shadows that show their weight.

+

Repeating patterns of scales or scalloping add layers of evident protection.

FUR CLOAK

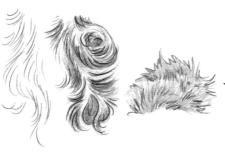 +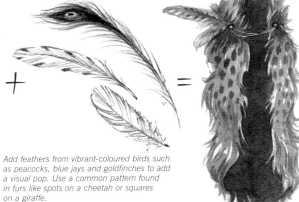

Draw fur soft and fuzzy, using lines that resemble wisps of hair. Use short lines for short fur, and wavy, curly lines for long fur. Draw the lines only where there is a change in direction or layers. Do not draw every hair.

Add feathers from vibrant-coloured birds such as peacocks, blue jays and goldfinches to add a visual pop. Use a common pattern found in furs like spots on a cheetah or squares on a giraffe.

PETAL BLOUSE

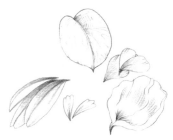 + =

Use direction lines only to convey the folds within the petal. Most flower petals are in the shape of a heart stretched out, fattened, or with additional sections.

Patterns that work well with petal textures are often floral and mimic the shape of petals. These can be very elaborate and highly decorative.

=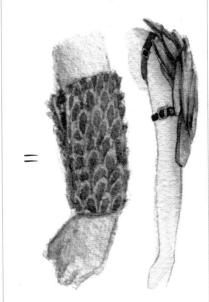

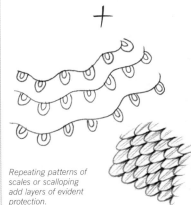

Hair

A fairy's hair not only describes her ethereal, magical self, but quite possibly her origins or lifestyle. If a fairy is always on the move and highly active, her hair would most likely be up in a ponytail or styled in a short pixie cut. A fairy who spends her time reading and sewing may have her hair down and long, whereas a fairy who paints might have her hair in a bun with twig pencils sticking out! With so much beauty around them and a diet consisting of berries, nuts and honey, they have some of the most silky, vibrant and elegant hair. Draw the hair as smooth, silky waves and create the most elaborate hairstyles your imagination can come up with!

RULE

26

Never create hair strand by strand

Don't draw the hair out strand by strand; instead draw it as a shape or gesture. Hair flows in sections, lying down upon itself. Start with a basic outline of the head shape, then draw the outline of the hair from top to bottom – a simplified form to follow. Then break the hair down into smaller sections, creating the volume and depth needed. This will make it less complicated and easier to manage. Main sections, such as the hair in front of the ears or parts pulled back into a plait, can take their own shape. Try to keep it as simple as possible.

SHORT PIXIE CUT

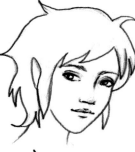

STEP 1
Create an outline around the head, using short strokes to create tips for a fringe, tight cuts around the nape of the neck and some on top where hair might pop up.

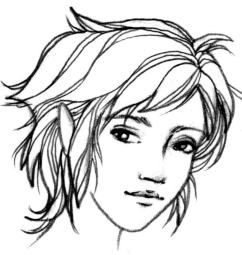

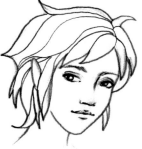

STEP 2
Find the parting in the hair by locating the largest split between two fringe sections. Begin to divide the hair from the parting, with sections going right and sections going left. Draw a few sections to show hair flowing behind her ear as well.

STEP 4
Add wisps and additional hair strands from the part near her face, from the ears and down by the nape of her neck to add further volume.

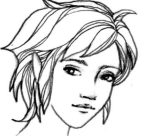

STEP 3
Add depth to her short pixie cut by adding multiple smaller sections within the larger ones previously drawn. Hair that is tucked under or behind will have far more lines than the broader ones on top.

FAIRY BUNS

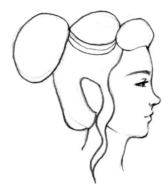

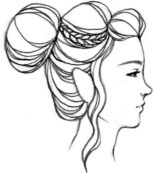

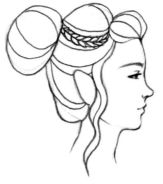

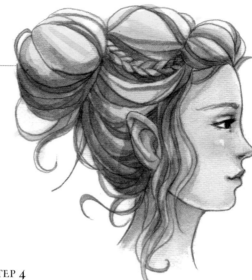

STEP 1
Use a small oval for her pulled-back fringe and a large oval for her bun. Draw the outline shape of the plait to help you stay organised.

STEP 2
Lay in the plait and sections (see page 49). The sections follow the shape of the oval from one end to the next, curving. Do the same with the hair being pulled back into the bun, as the head itself is curved.

STEP 3
Add smaller sections under the bun and from the ears down to add weight to the hair, rather than the top.

STEP 4
Finish with flowing wisps and strands, creating a very romantic hairstyle.

LONG LOCKS

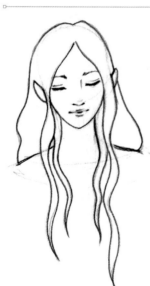

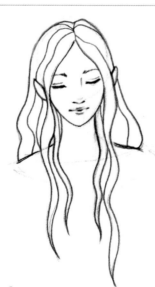

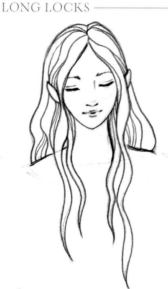

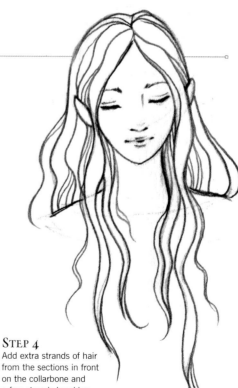

STEP 1
Draw a basic hair shape in front of the ears laying on top of the collarbone, and the bulk of the hair behind the shoulders. This will suggest not only the length, but also the amount of hair hidden from view.

STEP 2
Section out the hair from the parting, the middle point you began with, drawing lines that meet up with the shapes in front of the ears and some lines creating sections behind the ears.

STEP 3
Develop the tighter sections – primarily, behind the ears and near the neck and ears.

STEP 4
Add extra strands of hair from the sections in front on the collarbone and a few strands breaking free from the hair behind the shoulders.

RULE
27

Give hair a life of its own

This is a great method when you want to draw hair that is wind blown, curly or a relaxed style and allows you to be a bit more free and confident with your hair drawing. Simply draw the head shape, pick a direction to draw the hair in, start from the parting, and draw a few gesture lines to give the hair some guidelines. From there, complete the hairstyle by building up the sections and adding the final wisps.

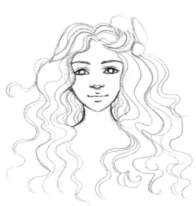

PLAYFUL CURLS

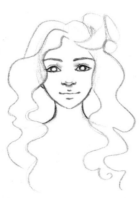

STEP 1
Begin with a head shape and create your gesture lines, starting at the centre of the forehead. Make the gesture lines wavy, with a variety of small and large waves. Add in small circles and ovals for the flowers in the hair.

STEP 2
Add sections to create high volume, following the first gesture waves as you go. This creates a harmony to the waves. Keep the smallest sections near the neck and face.

STEP 3
Complete the hair by adding curly wisps and closing off the ends with wavelike curls layered over each other.

WINDBLOWN HAIR

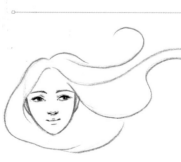

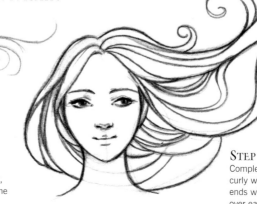

STEP 1
Draw out the face shape. Starting at the parting, draw the gesture lines with the greatest movement. For this hair, it would be the strands on the right. Create broad curls upwards. On the left, keep the hair moving toward the back of the neck.

STEP 2
Add sections large and small, keeping the smaller sections near the nape of the neck, ears and near the heavy curves, like the one in the centre here.

STEP 3
Complete the hair by adding curly wisps and closing off the ends with wavelike curls layered over each other.

28

Embellish!

Fairy art gives you the opportunity to embellish at every stage, and hair is no exception. You can add plaits, curls, accessories, flowers, jewels – or all of these – to your hairstyles to add character, symbolism or simply aesthetic decoration.

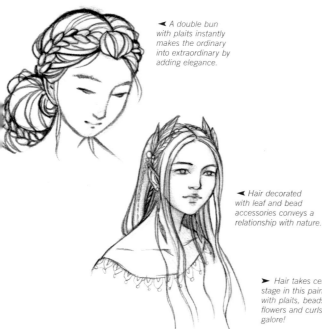

◄ *A double bun with plaits instantly makes the ordinary into extraordinary by adding elegance.*

◄ *Hair decorated with leaf and bead accessories conveys a relationship with nature.*

► *Hair takes centre stage in this painting, with plaits, beads, flowers and curls galore!*

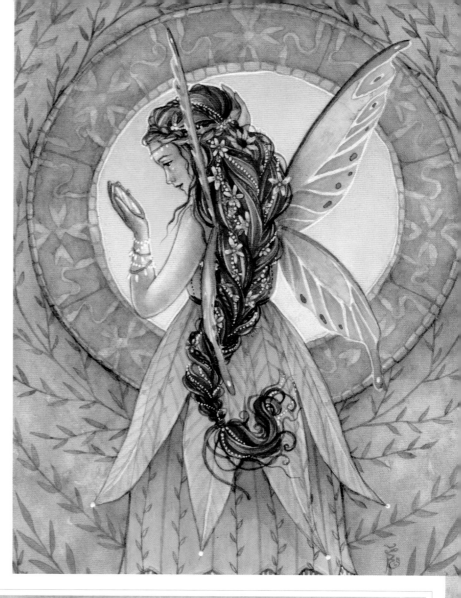

HOW TO DRAW A PLAIT

Plaits are very common for fairy hair and add elegance to the simplest locks. They are also quite simple to draw!

STEP 1
Draw two lines parallel to each other. This equals the width of your plait.

STEP 2
Divide the plait width in half and draw in angled ovals one after the other on one side.

STEP 3
Add in the other side, using ovals going in the opposite direction and slightly out of alignment with the first side. The angle of the ovals should mirror each other.

STEP 4
Finally, draw over your ovals, making them into more of a teardrop shape toward the centre of the plait. Cut off the end and add a tie, while at the top open the plait up into the hair.

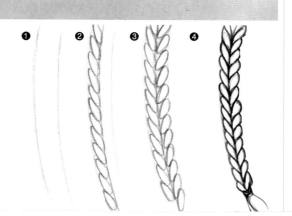

Establishing a location

Fairies can be found in almost every place, from high in the trees tinkering within a birdhouse to low down inside volcanoes twisting around whirlwinds of fire. When you think of fairies, not only do you gather imagery in your mind about what they look like, but you also begin to envisage what surrounds them. They live among us, but hidden from our eyes (unless they want to be seen), so they might be in the garden next door, or even taking a bath with the birds in a marble birdbath. Take a walk through the park or forest and imagine fairies flying about in and out of the leaves, swooshing above your head.

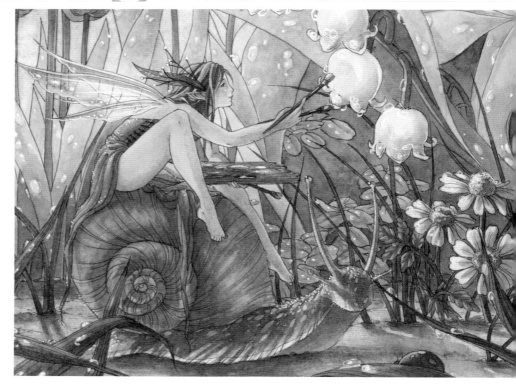

▲ *Take the perspective of a snail and see grass, flowers, and the ground environment from its point of view.*

RULE

31

Supersize the natural world

Fairies are often portrayed as small beings that live within nature, often no taller than a mushroom or dandelion. Enlarge the world around your fairy by creating a larger-than-life environment. Add flowers and mushrooms that tower over her head, or creatures such as snails and bumblebees large enough for her to ride. From the bed she sleeps in at night, made of huge oak leaves, to the hat made out of an acorn shell on her head, supersize your fairy's world.

◄ *Utilise a toadstool in different ways – as a stage to make your fairy the centre of attention, or as a place of shelter or solitude.*

RULE

32

Make your fairy at home

When deciding on a location for your fairy, consider who she is and what she does. A snowflake fairy would be found in a winter wonderland, and a harvesting fairy would be found among pumpkins, mushrooms and barley. Your background will be much stronger if you have worked out the basics of your fairy's story, and you can use that information to help determine it. Make a small list of what could be found around your fairy to give you a better idea of what you need to incorporate.

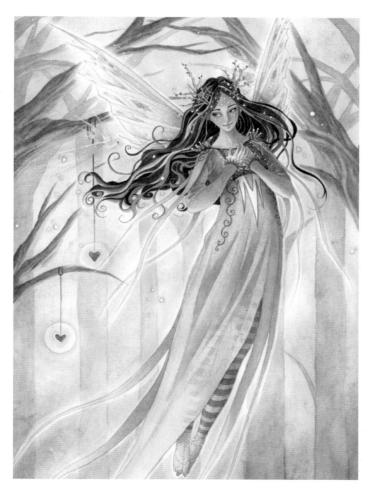

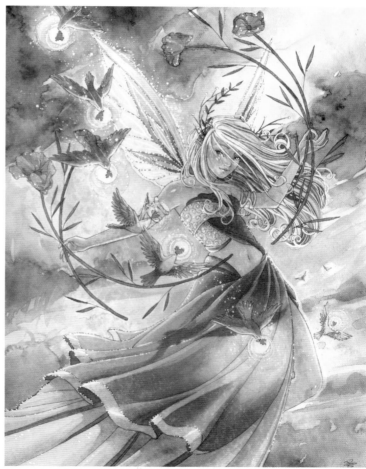

▲ *Surround a winter fairy with bare trees, cool colours of blue violet, and – most importantly! – snowflakes.*

▲ *For a graceful air fairy, fill the background with stormy clouds and birds.*

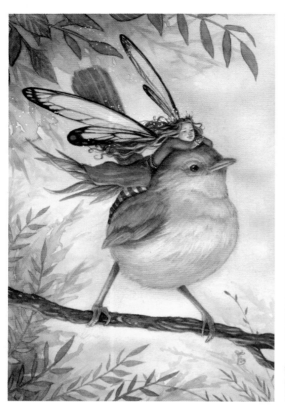

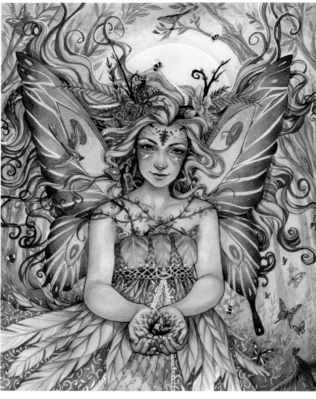

◄ *Far left: Keep the environment simple with leaves, branches and a soft colour palette in the background. This way the focus remains solely on the fairy and the bird, not distracted by what is surrounding her.*

◄ *Left: Engage the viewer with many elements, such as trees, foliage, butterflies, birds and patterns, in all three of the image's plains: the foreground, middle ground and background.*

▼ *Find a balance using both a diffused but detailed background. Select just a few props, such as a flower, birds, and a painting, to help tell a story. By limiting the elements, you engage with movement and storytelling without overwhelming the fairy's environment.*

RULE

33

It's all in the detail

When you create your background, think about how much detail is necessary. To keep the focus on the fairy or something specific, allow the background to drop further away with minimal detail. Use softer edges, limited colours and simple subject matter such as foliage or a texture. If the image portrayed is to be complex with many different elements or parts to its story, then fill the paper with background details such as trees and foliage, and create a middle ground with the fairy, butterflies and a bird. Finish with some elements in the foreground in front of the fairy, such as a bird or more foliage. This creates movement and dimension to engage the viewer.

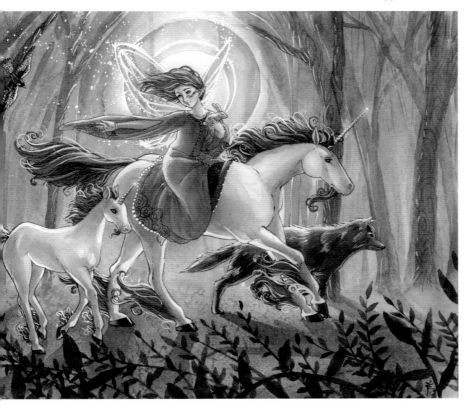

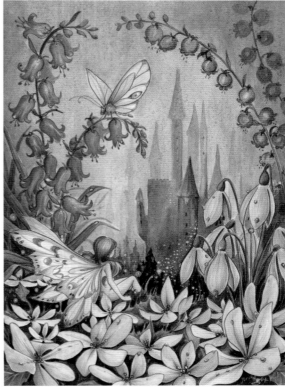

▲ *Place a bright halo and fairy dust behind and around the fairy to highlight her, and show her companionship with magical and majestic creatures such as unicorns and wolves in an enchanted forest.*

▲ *You don't need fairy dust and stars to make an environment magical; the perspective, colours, and fairy's interaction with her space can make it feel enchanting, as here in Joanna Bromley's Twilight Fairy Castle.*

RULE

34

Backgrounds should portray magic

Fairies are an expression of the impossible being possible, and your backgrounds should take your viewers into a world where they can believe that anything can happen. Try to incorporate a little magic here and there in the location, so that you can share how special the place is: consider adding stars and will-o'-the-wisps, orbs of light and magic, a simple breeze with fluttering butterflies and leaves, Celtic knot work and swirls, or magical creatures such as unicorns. These are all common and important elements among fairies and their magic.

Composition & placement

Before you begin a painting, compose the picture with a plan in mind. Avoid drawing your fairy in the middle of the canvas and adding a background as an afterthought. Think about where she is and what her surroundings are. How is she interacting with the scenery? If there is a story, you will want to find the best format to tell it. Small, loose sketches called 'thumbnails' can be made to help you decide on a final composition. Thumbnails shouldn't take long, so it's easy to experiment with several designs or viewpoints to help you form your ideas.

RULE

35

Think beyond the centre

Use a symmetrical composition if you want a sense of stability and immediate focus on your fairy. A centred composition is more design oriented than narrative, and can lack movement. Provide variety by using an asymmetrical picture with extra background elements, but try not to draw everything to one side. If you find your composition is weighted to one side, stop and rethink how it can be balanced.

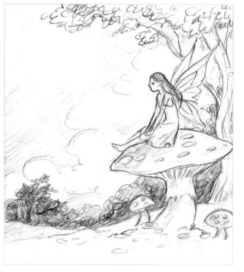

This is a centred composition as all the elements point toward the centre. The focal point is clear, but it lacks variety.

This is an asymmetrical composition; the focus is moved to one side, but distant trees in the corner provide balance to the taller fairy and mushroom.

FLIP THE PAPER AROUND

Vertical, or 'portrait', compositions work well for close-ups and portraits. To tell a story, try drawing a horizontal, or 'landscape', composition instead. The extra space will allow you to show the open expanse of a landscape or the slow passage of time.

Here, the vertical sketch seems crowded, but the landscape format allows us to see more of the setting.

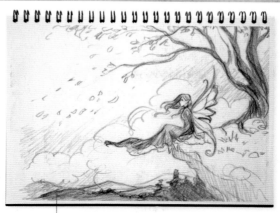

Horizontal (landscape) format

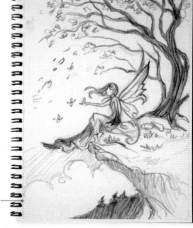

Vertical (portrait) format

RULE

36

Create a focal point

Choose a centre of interest for your painting. It might be something your fairy is looking at or travelling towards, or simply her face. Make use of directional lines and elements in your composition to draw the viewer's eye towards the focal point. This could be a path or line of trees leading into the distance or small fairies or animals looking in the direction of a larger figure. Flying birds, butterflies or blowing leaves and arching plants pointing to the figure are equally effective.

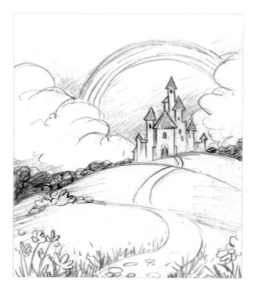

The winding path helps to draw the viewer's eye to the castle, which is framed by the rainbow. The clouds and distant trees form shapes that point toward the castle as well.

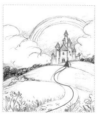

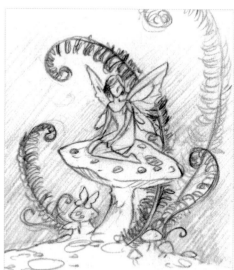

Use the slope of the ground and the arching shapes of the ferns to create a frame around the fairy.

Lighting

Light and shade make your drawings and paintings look three-dimensional. When light doesn't hit part of an object, its shape can be revealed by the shadows it creates. You need to establish the light and shadows for your fairy to be believable. Fairies dancing under a full moon would be lost without moonlight, while the magical light radiating off a fairy's wings helps the viewer understand how she takes flight. Understanding where the light is coming from will help you determine where your lights and darks should be. Not only that, but it will also help your viewer understand what is happening or why.

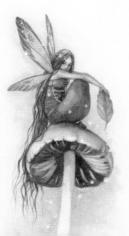

RULE

40

Establish the direction & quality of light

Before you even think about painting, you must first decide where you want your light source to come from, and how it will land on your fairy. It is important to resolve this now: with watercolour, once your paint is down, it is very difficult to lift and change it. Give yourself a road map by sketching out the shadows and establishing the direction of the light source first. You can do this in a sketchbook, loose leaf or on the watercolour paper itself if you're feeling confident. You also need to decide on the type of light emitted by your light source – this affects the quality and colour of the light and therefore the mood of the painting.

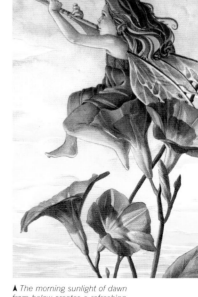

▲ *The morning sunlight of dawn from below creates a refreshing light on the fairy and flowers.*

▼ *Light coming from the lantern in front of the fairy creates an enchanting moment between her and the lilies.*

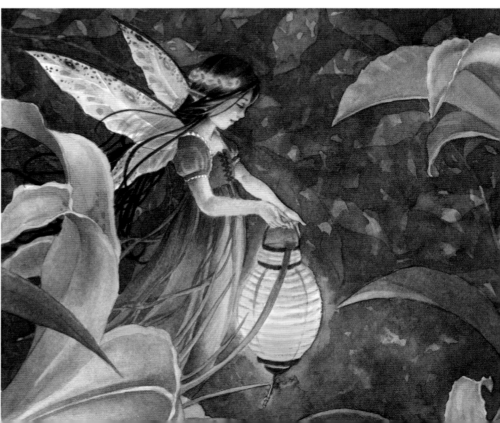

RULE

41

Use light & shadows to describe form

Highlights are created where light hits an object. Shadows fall where no light reaches an object. So this information tells us the shape of that object. Practise applying this theory to basic shapes before building up to complex areas such as faces, limbs and hands.

——— LIGHT AND SHADE ON SHAPES ———

Practise using light and shadow by drawing four spheres. Crosshatch in the shadow for each one, making sure that the shadow follows the shape of the sphere; the position of the shadow will depend on where the light is coming from. Leave the white of the paper to show where the light is hitting the sphere.

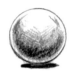 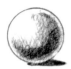 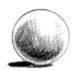 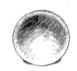

Light comes from above; shadow falls in front.

Light comes from the top left; shadow falls to the right.

Light comes from the top right; shadow falls to the left.

Light comes from below; shadow is almost nonexistent.

——— LIGHT AND SHADE ON FACES ———

Next, apply the same light source to faces. Quickly sketch out four faces and lightly sketch in the shadows, following the shapes, dips, and angles of each face.

Light from above creates a strong shadow below the ball of the nose, under the chin and near the eyelids.

Light from the top left casts a heavy shadow from the eyebrow to the lips. Hair behind the neck is shadowed, as well as the hair on the right side of the head.

Light from the top right creates a shadow where the hair overlaps with the face, and most of the lower left part of the face.

Light from below creates an entirely different effect by casting shadows under the eyes, on the bridge of the nose and above the eyebrows.

TROUBLESHOOT DIFFICULT AREAS

The light source for the fairy in this image is her pendulum. This unusual angle means it can be tricky to work out where the light and shadows fall. Work them out by troubleshooting these areas before you start painting.

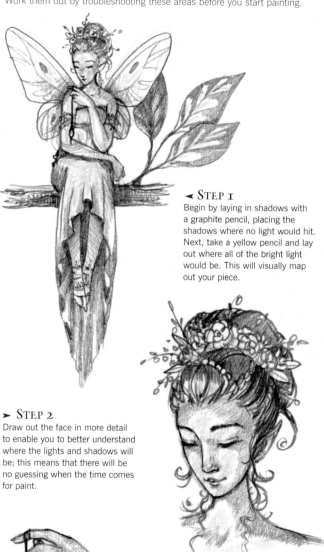

◄ **STEP 1**
Begin by laying in shadows with a graphite pencil, placing the shadows where no light would hit. Next, take a yellow pencil and lay out where all of the bright light would be. This will visually map out your piece.

➤ **STEP 2**
Draw out the face in more detail to enable you to better understand where the lights and shadows will be; this means that there will be no guessing when the time comes for paint.

◄ **STEP 3**
Zoom in and draw out tricky parts of the fairy or environment to study the light further up close. This will also help you determine if you need a reference or not.

Making an underdrawing

Your initial sketches will allow you to sort out the content and composition of your painting, as well as the tonal values. Now comes the exciting part – getting ready to paint! Don't rush in, however. Unless you're really confident about your painting skills, it's a good idea to do a very light pencil sketch, or underdrawing, on your watercolour paper first, so that you can map out where the key elements go. You don't have to include everything – just enough to allow you to keep track of where you are when you start painting and to remind yourself of such things as tonal values, colour choices, textures and patterns.

Create an outline of the tops of your trees and the sections coming from branches. Keep the shape organic and irregular, thinking of leaves as you draw this out. Draw a few individual leaves, varying the size from large to small. Bunch up many leaves together near branches and where the eye sees them the closest. From there, spread them out into the vastness of the treetops.

RULE

42

Keep it light & simple

First, decide how much you need to draw in before you start painting. If you're afraid you might forget the shape of particular flowers, draw a few but leave the rest basic so that you don't muddy your paper. Add in some leaves where they are closest to the viewer, but don't draw every single one. And keep your pencil marks light, so that there's no risk of them showing through in the final painting (unless that's what you want, of course) or muddying the paint.

Lightly sketch in the rocks or cliffs in the background, along with light lines for the water. Keep these simple and non-descriptive, as they are too far away for the eye to make out every little detail.

Draw in the folds of the fairy's clothes only as much as you need, keeping them flowing in the same direction for consistency. The tighter folds are towards the top, near her waist and hands.

Give the grasses closest to the viewer, in the foreground, the most details and thought – unlike the ones to the right or all the way in the background. This helps to convey a sense of recession.

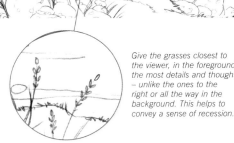

Lay out the tree bark loosely, adding the most lines near knots and where the branches twist. The lines are long and flowing like the water, connecting to each other and to the outline of the tree.

Keep detail in far-off buildings or structures minimal. If there are lights on in the windows, sketch them out to stop yourself from painting over them. Any details of what the structure is made out of will be lost through the atmosphere, so there no need to draw it in.

Add little spirals at the ends of waves where they meet up with the land. When describing a cliff, show the changes in colour by sketching out lines where the rock transitions and curves. Grasses that meet up with the rock are made with short strokes, similar to short fur or hair.

Draw out the flowers, keeping their shape simple without too much detail so that when you paint, you have a clean surface void of any pencil. Flowers with petals can have lightly sketched-in lines to guide your brush if needed.

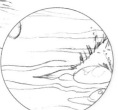

Add soft, broad lines for waves radiating out from the rocks, setting them further apart from each other the farther out from the shoreline you go.

TRANSFERRING YOUR DRAWING TO WATERCOLOUR PAPER

If your painting is going to be the same size as your initial compositional sketch, you can just lightly trace it onto your watercolour paper. To transfer your drawing or final sketch to watercolour paper, use a light box, your window on a sunny day, or place an electric light under a glass table. This method of using light is the cleanest, simplest and most flexible way to transfer your initial sketch to the paper you're going to paint on.

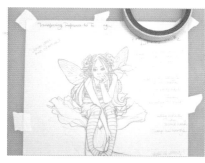

STEP 1
First, tape down your drawing onto your light box, using masking tape. Tape every corner and every side, making sure the paper is flat and tight. If you are using a window, tape the drawing onto the window at a comfortable height for your hand.

STEP 2
If you are using a light box, make the room as dark as possible, as this will allow more light to go through the paper and show your lines more clearly. Turn on your light box (if using) and place your watercolour paper over the drawing. Line up your paper and tape down the corners and sides to the light box or window, as in Step 1.

STEP 3
Begin tracing your image, working from left to right if you're right handed, or from right to left if you're left handed. This will keep your pencil from smudging as you trace. Use a graphite pencil and make only light marks. Once your piece is entirely traced, gently peel off all the tape. Take both drawings back to your workspace and compare, making sure you traced everything, and adjust if necessary.

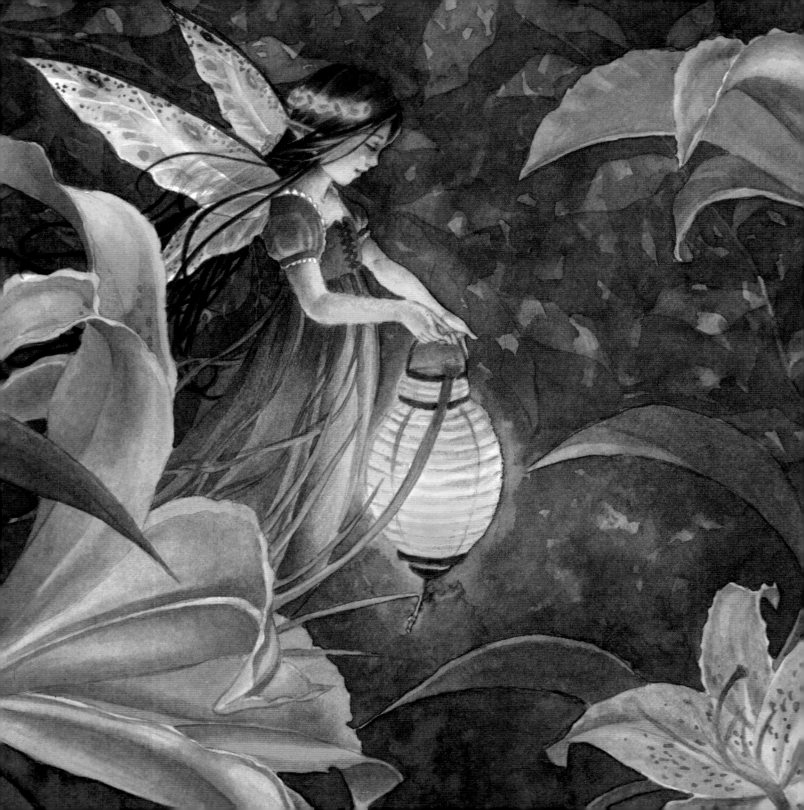

2 Rules for watercolour

Learn the key watercolour painting techniques, from prepping paper and masking to wet on wet, wet on dry, blending and glazing. Use the magical methods for creating texture with everyday items, add details to create depth, and most importantly, learn how to use colour palettes. Bring your story to life by adding strong and expressive paint to your watercolour fairy art!

Painting tools & materials

Watercolours are an exciting medium to work with when painting fairies. They provide translucent glazes that create soft and whimsical qualities and fun textures, and are available in a vivid array of colours. There are a few basic tools you will need to start a watercolour painting, but there are also tools that can be added along the way. Watercolour provides endless possibilities!

Setting up your workspace

It is important to set up your workspace so you can reach everything and it's easy to move from water, to paint, to paper, over and over again with the least amount of drips and spills. Place your palette, water and paper towels on the side you write with. Keep these three close together, as you will go back and forth between them. Your brushes and any extra tools can be above your paints and paper. References, if being used, can be on the opposite side to the palette. Place your paper in the centre. It is best to keep your table flat, especially in the early stages of a painting when more water is used.

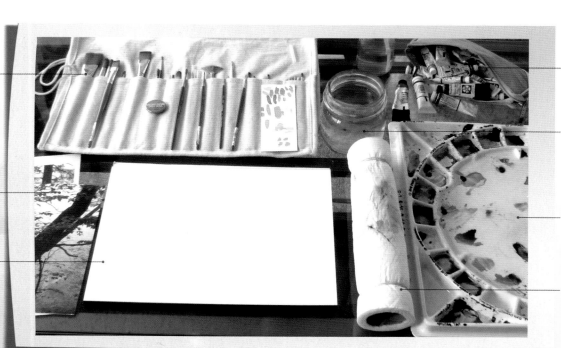

Paintbrushes laid out above paper in the centre for easy viewing and accessibility.

Reference materials stacked on the opposite side of the palette.

Watercolour paper or block placed right in the centre of everything at a comfortable height from the edge of the table for working.

Place paints above the palette to easily add more paint or to find a different colour if needed.

In the centre is the primary ingredient to watercolour painting – water.

Palette is flat, on the side of the writing hand, near the water and paper towel.

Paper towel placed between the paper and palette to catch any drips and to make it simple to dab a brush of excess water.

Brushes

There are many different types of brushes to choose from, made from sable, synthetic and blended hairs. Sables are considered the best and hold the most water when painting. They are also the most expensive, because they are made with natural hairs. Synthetic brushes are man-made brushes that have a spring or bounce in their bristles, but they don't hold as much water as the sable, and they are often the least expensive. Then there is the blended-hair brush, which is midway between a sable and a synthetic. A blended brush will hold enough water while keeping its bounce, and they are reasonably priced.

The brush size you choose will depend on your project. Brushes are sized from number 0000 (the smallest) up to 14 and over for the biggest.

Square or flat brushes create flat background washes and angled broad strokes that lay in large areas of colour, as well as achieve some crisp edges. Round brushes are ideal for details, consistent lines and irregular washes.

Other watercolour brushes include the rigger, which is good for extra-fine straight lines – something a bit more difficult to get from a stubbier round brush – and the fan brush, which, when wet becomes multiple riggers in one and is perfect for creating grasses and striped textures for trees, water and fur. There are other brushes not for painting, but for lifting, such as the brightener, which has short, stiff bristles and is used to gently lift paint from the paper.

Find a brush holder to protect your brushes when they are not in use. They come in canvas, bamboo, nylon and plastic. You can even wrap your brushes up in a napkin tied with a ribbon until you can get something more permanent.

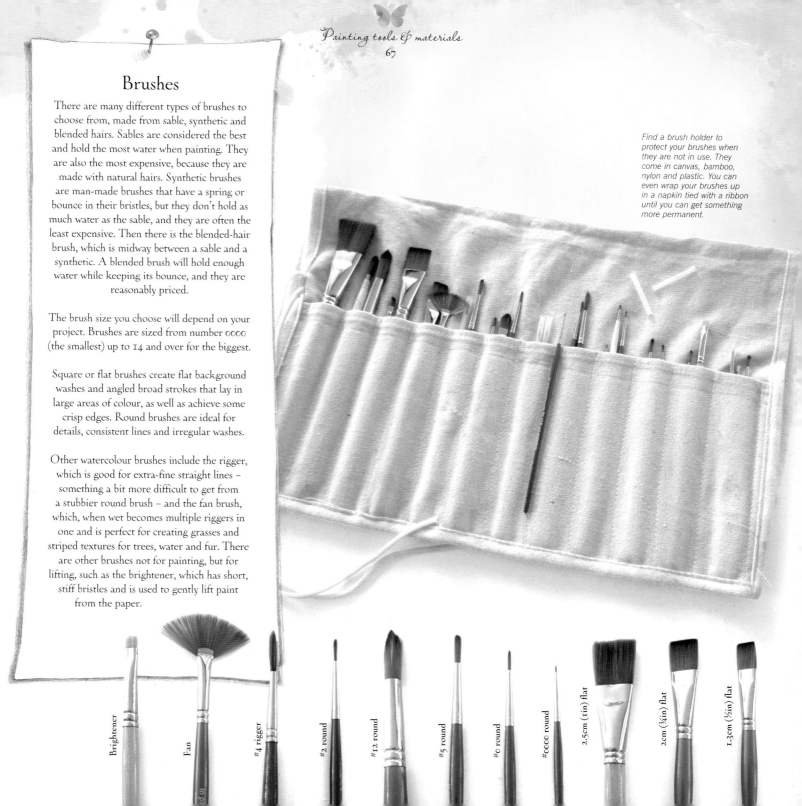

Brightener

Fan

#4 rigger

#2 round

#12 round

#5 round

#0 round

#0000 round

2.5cm (1in) flat

2cm (¾in) flat

1.3cm (½in) flat

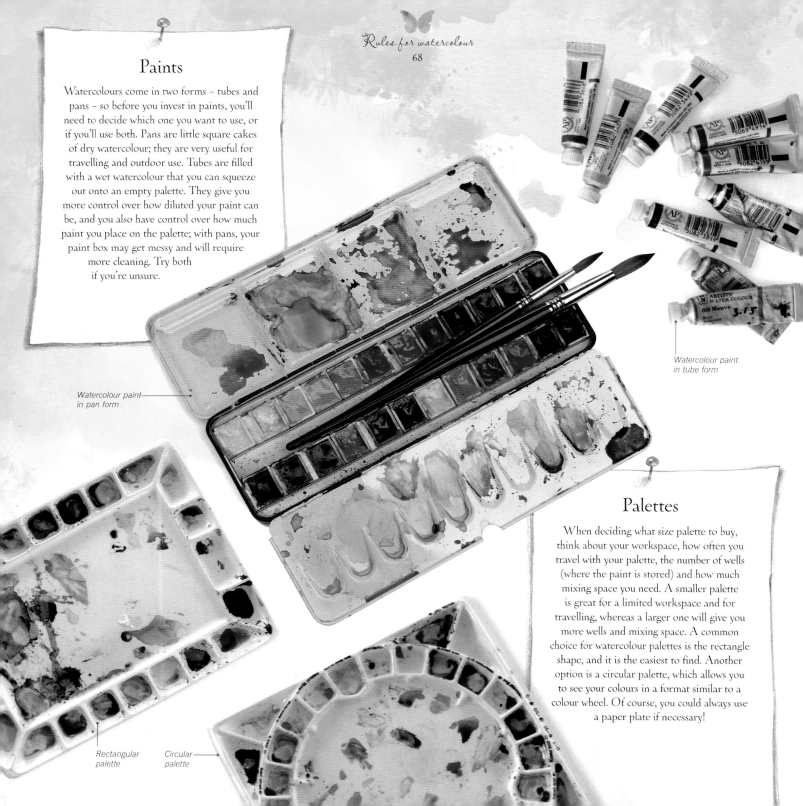

Paints

Watercolours come in two forms – tubes and pans – so before you invest in paints, you'll need to decide which one you want to use, or if you'll use both. Pans are little square cakes of dry watercolour; they are very useful for travelling and outdoor use. Tubes are filled with a wet watercolour that you can squeeze out onto an empty palette. They give you more control over how diluted your paint can be, and you also have control over how much paint you place on the palette; with pans, your paint box may get messy and will require more cleaning. Try both if you're unsure.

Watercolour paint in pan form

Watercolour paint in tube form

Palettes

When deciding what size palette to buy, think about your workspace, how often you travel with your palette, the number of wells (where the paint is stored) and how much mixing space you need. A smaller palette is great for a limited workspace and for travelling, whereas a larger one will give you more wells and mixing space. A common choice for watercolour palettes is the rectangle shape, and it is the easiest to find. Another option is a circular palette, which allows you to see your colours in a format similar to a colour wheel. Of course, you could always use a paper plate if necessary!

Rectangular palette

Circular palette

Papers

Choosing your paper is an important step in creating a strong and successful painting. Higher-grade or hand-moulded papers will provide better absorption, colour output and consistency. A lower-grade, machine-made paper is best for practice and sketching as it does not hold water as well and makes glazing tricky.

Papers are primarily categorised according to their paper texture. Cold-press and rough papers are the most commonly used, and will absorb your watercolours and their pigments quickly, allowing many, many glazes, and they have a tooth texture. Hot-press papers and boards have a smooth texture and are best for fine detail, more opaque colours and glazes.

COLD-PRESS WATERCOLOUR PAPER

Cold-press paper has a medium tooth, or texture, and will absorb water and pigment more readily, providing a surface that allows many glazes. It can handle a lot more lifting and erasing than a hot-press paper and is a good paper for beginners.

HOT-PRESS WATERCOLOUR PAPER

Hot-press paper doesn't take the watercolour nearly as fast as a cold-press would, but it provides a good surface for blending and high-end detail in a small space.

ROUGH WATERCOLOUR PAPER

Rough papers have the most tooth, or texture, and hold a lot of water. They are commonly used for paintings requiring washes and heavy amounts of paint, and take the most control.

COLD- AND HOT-PRESS ILLUSTRATION BOARD

Illustration board is a great alternative to watercolour paper. It doesn't have to be stretched down with water; instead, it can be taped onto a drawing board to be moved about. Illustration board does have its limits in terms of how many glazes it can accept and how much water it can hold, but it is still a great choice for a beginner to use.

Other equipment

To use the paint, papers and brushes, you will also need some additional equipment to get your painting started.

WATER CUP

A water cup is an essential. It is helpful to have a clear jar or bowl so that you can keep an eye on the water's colour and to have a sturdy shape so that you don't have any spills. Anything will work as your water cup, but keeping it low and clear will give you the best performance when painting.

PAPER TOWELS

Absorbent paper towels for dabbing your brush or wiping away unwanted water from your brush are essential. You can fold several sheets together or use a whole roll with rubber bands at the side. This method allows the most absorbency.

TAPE

You will also need tape to stretch or tape down your paper to keep it from warping as you paint. See pages 76–77 for the different options and for how to stretch paper.

COLOUR WHEEL

Keep a colour wheel handy around your workspace. It can be a great tool in helping you choose the best colour palette, solve a colour-mixing problem, or answer any colour theory questions.

Many colour wheels have colour groups and colour mixing tips printed on them to help you.

Colour

Choosing colours can be intimidating, given the hundreds there are to select from. It is good to know a little colour theory. This sounds complex, as there are lots of technical-sounding terms, but once you grasp the basics, you'll be amazed at how much difference it can make to your painting. The more you play with colour, the more options you will disover, the more fun you will have and the more depth you will achieve in your paintings.

RULE

43

Get to know the colour wheel

It is helpful to understand some basic theory about the qualities of individual colours and the way they interact with other colours. The colour wheel visualises this information.

Red, blue and yellow are the three primary colours, so called because they cannot be mixed from other colours. These are evenly spaced around the colour wheel. Mixing two of these primary colours together produces a secondary colour, orange (red and yellow), green (yellow and blue), or purple (blue and red). These are positioned in the middle of the primary colours on the colour wheel. If you mix a primary colour with a secondary colour, you'll produce a tertiary colour. You'll find these between the relevant primary and secondary colours on the colour wheel.

There are several recognised colour harmonies based on the colour wheel. They can be a good starting point for picking out colour palettes.

Mixing colours that are next to each other on the colour wheel produces harmonious and often vibrant blends, while mixing colours that are opposite each other produces more neutral and muted shades.

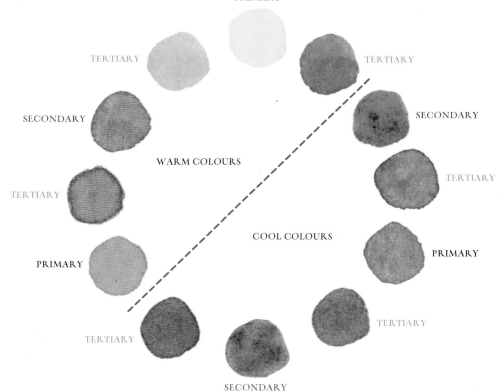

PRIMARY

TERTIARY

TERTIARY

SECONDARY

SECONDARY

WARM COLOURS

TERTIARY

TERTIARY

TERTIARY

COOL COLOURS

PRIMARY

PRIMARY

TERTIARY

TERTIARY

SECONDARY

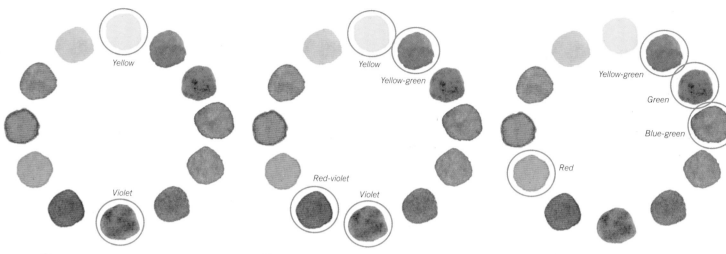

COMPLEMENTARY palette

Complementary colours are any two colours directly opposite each other on the colour wheel. Use this colour group to create stunning fairies who use a lot of light or need to stand out from their environment.

DOUBLE COMPLEMENTARY palette

Increase the intensity of a complementary pair by using four colours of the same pair. For example use yellow-green and yellow against red-violet and violet. Use this colour group for flower, royal and earth fairies. Any time you need bold colours with a delicate harmony, these work well together.

SPLIT COMPLEMENTARY palette

Take a single colour, such as red, and place it against three of its opposites on the wheel, such as yellow-green, green, and blue-green. Use a split complementary palette for daytimes such as dawn, dusk and midnight. These bring focus to the central figure or light source.

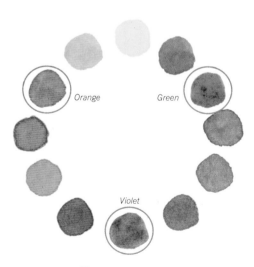

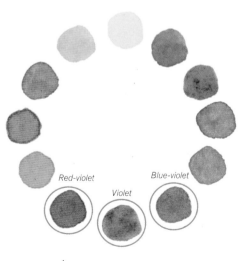

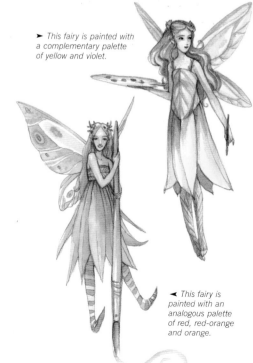

➤ *This fairy is painted with a complementary palette of yellow and violet.*

TRIADS palette

Pick a colour on the colour wheel and choose two more colours equal from it and each other. Colours at each point of an equilateral traingle on the colour wheel will be traids. Create bright and playful pixies, magic and elemental fairies with this colour group. It is best if you let one of the three colours dominate and use the other two in lesser amounts.

ANALOGOUS palette

A simple group of colours to use, analogous means the colours are right next to each other on the colour wheel. This prevents any colour contrast but does create a strong and bold mood. Use this colour group for fairies showing strong emotions or an outfit that would suggest a type of mood or element.

◀ *This fairy is painted with an analogous palette of red, red-orange and orange.*

RULE

44

Mix your own colours

In watercolour painting, there is not just one blue, one red and one yellow – there are many different versions of each primary colour, each with their own characteristics. Starting to mix different sets of primaries will give you multiple different secondary colours that all have their own mood or tone. The violet that springs from mixing a warm red with a cool blue would be completely different from the one created by mixing a cool red with a warm blue. Mixing your own colours will almost certainly, if not always, give you colours of more depth than those premixed for you.

Experiment with several primary palettes. Gather three different reds, three yellows and three blues. It is good to have some cool and some warm tones.

Begin by choosing one red, one yellow and one blue and begin to mix them to create a secondary palette. Next pick a different red, yellow and blue and mix to see what secondary colours you get. Rotate around until you've mixed all of them with each other. Take notes to remind yourself what colours you mixed together. When you mix, try to keep an even amount of each colour; for example, when you mix a red and blue, if you add too much red, your violet will be more of a red-violet.

To create even more variety, you can also use colours that aren't typical reds or yellows, but are similar, like a Burnt Sienna for the warm yellow or Prussian Blue for the cool blue.

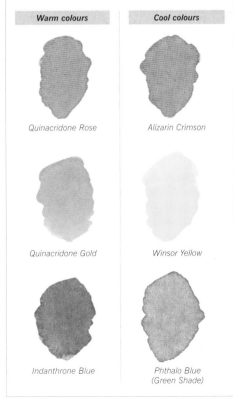

WARM AND COOL COLOURS

Colours are often described in terms of 'temperature', with blues and blue-greens described as cool and reds and oranges as warm. But it is not quite as simple as this, because each colour, including the primaries, secondaries and so-called neutral colours, has a warm and a cool version. The slightly blue Alizarin Crimson, for example, is cool in comparison with Cadmium Red, while Ultramarine Blue is warm in comparison with the slightly greenish Prussian Blue. The concept of warm and cool colours is very important in painting, as it allows you to create a sense of depth. As objects become more distant, the colours become paler and cooler, so by using warmer colours for your fairy figures, you will make them come forward in space.

Warm colours	Cool colours
Quinacridone Rose	Alizarin Crimson
Quinacridone Gold	Winsor Yellow
Indanthrone Blue	Phthalo Blue (Green Shade)

Phthalo Blue (GS) (cool)

Cadmium Scarlet (warm)

Winsor Yellow (cool)

Cobalt Blue (warm)

Cadmium Scarlet (warm)

Winsor Yellow (cool)

Alizarin Crimson (cool)

Cobalt Blue (warm)

Quinacridone Gold (warm)

Prussian Blue (cool)

Quinacridone Rose (warm)

Burnt Sienna (warm)

EXTENDED PALETTE

To create your colour palettes, you may find it useful to introduce some secondary colours. This is called an extended palette: colours you could mix on your own with your primaries but that are purchased to reduce mixing time.

Burnt Umber
A base brown used for mixing great skin tones, tree bark and earth tones.

Sepia
A neutral earth tone, good for darkening other earth tones.

Lamp Black
This is used for making rich midnight blues, dark brown hair and enchanting eyes.

Phthalo Green (Blue Shade)
This creates strong blue-greens like turquoise.

Sap Green
A warm green for foliage and gardens.

RULE

45

Create your own colour palettes

Creating palettes from the colours you discover as you mix is great fun, as you begin to envisage a pastel palette with a flower fairy, or a bold palette for a summer fairy. Finding a number of colour palettes to choose from will give you references for when it comes to painting. They are great to have alongside your workspace or attach them to your inspiration board.

Every artist has an eye for certain colours they gravitate towards and then turn to these colours when painting. Some prefer more muted colours like earth tones, and some prefer those of pastels, or bright and bold. These colour palettes are great starting points in choosing well-balanced colour palettes found in nature, creating lush and beautiful harmonies.

Use these colours to describe your fairy's season, role, element or type. A gentle wind fairy may be dressed all in pastels, whereas an autumn fairy might be dressed in a more natural palette. Look to the things surrounding you that you are visually attracted to and you'll see the colour palette you lean towards. Use the colours you find to create your next piece.

Colours used (from left to right):
Burnt Umber, Alizarin Crimson, Quinacridone Gold, Indanthrone Blue

EARTH TONES
Use this earthy palette to create a warm autumn fairy dressed in muted earth tones with a golden glow of harvest.

Colours used (from left to right):
Pyrrole Orange, Aureolin Yellow, Phthalo Blue (Green Shade), Phthalo Green (Blue Shade)

BOLD TONES
Create lush and playful costumes full of feathers, leaves and flowers for a summer fairy, or a dazzling dress reflecting light for a water sprite.

Colours used (from left to right):
Rose Madder, Cobalt Blue, Sap Green, Aureolin Yellow

PASTEL TONES
Add beautiful and soft pastels to create a cool and crisp palette for ice pixies, fairy snow queens or whispering wind fairies.

RULE

46

Use colour to create movement

Whenever you use a palette of colours – whether it be a group such as bold tones and earth tones, random choices or a traditional combination such as triad or monochromatic – it is important to find a balance in laying out the colours through the painting. Look at the composition and determine what should stand out and what needs to be pushed back. Know that cool colours tend to recede, while warm colours come forward, and consider not grouping all of them together. For example, placing only blues and purples throughout the background would be quite a challenge, and it could be too much on the eye. Add some yellows and reds, but be aware that they will be more in front than purple or blue elements. The same is true with your fairy, as she can have cool colours like blues and greens within her outfit or wings, but adding more warm colours will make her stand out further from her environment. This application works both ways; the background can be warmer and the foreground cooler. The goal of using warm and cool colours in balancing out the painting are to help the eye move. By making a visual path through the painting, colour will keep onlookers engaged in your fairy's world.

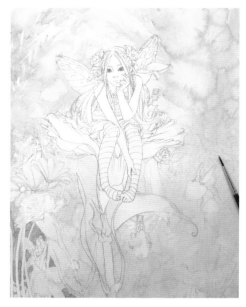

▲ STEP 1
Fill in the background with a green with added yellow to create a soft and airy atmosphere. Towards the bottom of the painting, add violet with a touch of red to bring that part forward.

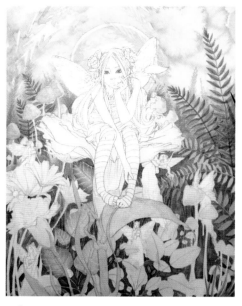

▲ STEP 2
Lay in most of the cool colours, such as violet, blue and green, to find a visual path. Apply red and yellow to the leaves, but notice that the colours don't pull the leaves too far forward because of how much violet and green is used.

STEP 4 ➤
Continue with the yellows, oranges and reds. Notice how they balance out the cools and move the eye around the central fairy, starting at the bottom left corner, up, around and back down to the lower right corner.

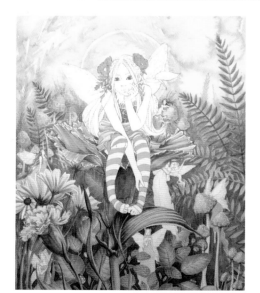

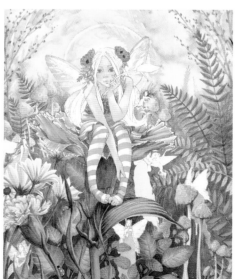

Colours used: ☑ Sap Green ☑ Pyrrole Orange ☑ Aureolin Yellow ☑ Alizarin Crimson ☐ Rose Madder Genuine ☑ Quinacridone Magenta ☑ Quinacridone Gold ☑ Ultramarine Violet ☑ Raw Umber ☑ Indanthrone Blue ☑ Phthalo Blue ☑ Phthalo Green

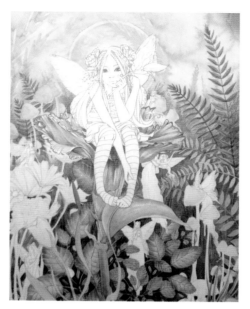

▲ STEP 3

Gradually begin to apply and intensify the warm colours.
Start with the flower in the middle, as it is central to the
piece. Paint with a bold, silky red – a colour also found
within the violet leaves below – to help draw both
elements together.

◄ STEP 5

For the fairy, choose
a cool colour that isn't
already commonly found
in the background. Add
a colour that will also
complement the ice blue,
such as a bold red. This
will make the blue look
crisper and more modern.
Also add soft violet
flowers, framing the fairy
in the background and
directing focus toward
her, without making
the eye battle with the
surrounding foliage.

STEP 6 ►

Add a bolder red than the
one used in Step 5 to the
bottom left of the fairy's
dress, and punch out the
mushrooms at the bottom
right to balance the piece,
creating an entry and exit
point. Apply a neutral
colour to the hair, such
as ivory or sepia, giving
the eye a resting place.
This allows time to focus
on the fairy's face and her
expression. Neutral colours
can create some calm
moments in a painting.

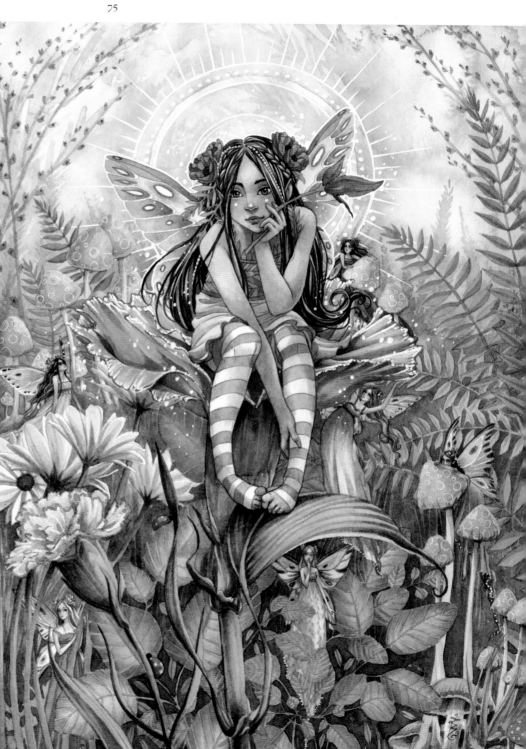

Preparing paper

Working with watercolours has many advantages, but naturally creates some problems when paper becomes soaked with water. By properly preparing the paper before painting, you make it easier to paint on and avoid having a wrinkled finished painting. If using a lightweight watercolour paper, there are some common steps that can be taken to prepare before setting brush to paper.

You will need: ☑ Watercolour paper ☑ Basin of water ☑ Gummed paper tape or acid-free masking tape ☑ Thick masonite or wooden drawing board

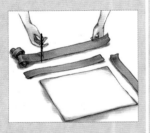

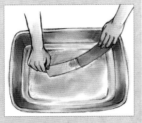

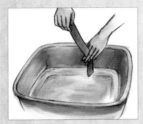

STEP 1
First prepare your tape. Cut four lengths of tape, each one 2.5cm (1in) longer than each side of the watercolour paper. Lay out your cut tape so that you have it ready.

STEP 2
Fill a bowl or sink with water and dip a strip of tape in to wet it. Then hold up the tape to allow the water to drip off.

STEP 3
Lightly run your fingers down the tape to remove any excess water. Don't press too hard, or you will remove the glue; the tape should be slightly sticky. Repeat Steps 2 and 3 for all pieces of tape.

STEP 4
Lightly stick the end of each piece of tape to the edge of your work surface or the sink so that it hangs in the air. The tape will stay wet for 3–5 minutes while you prepare the next step. If the tape dries too soon, you can usually rewet it – but be sure not to remove the glue.

STEP 5
Using a damp sponge, lightly wet the board on which you are going to stretch your paper and set aside. The damp board will help your paper to stick easily.

TIPS

Use alternative papers
If you don't like stretching watercolour paper or want to save time, consider painting on a watercolour block. Watercolour blocks are glued on the edges and already stretched, so they will stay flat. Thick watercolour boards and illustration boards are also a great alternative.

Other tapes and how to use them
Alternatives to gummed tape include:
• White artist tape holds the paper down firmly and resists the water well. It is less sticky than masking tape, so it's easier to remove.
• Brown paper packing tape can be used over artist tape to provide additional support, keeping the paper flat on the art board or table.

• Blue tape made for painting walls is made for easy removal and clean edges.
Always be careful and remove tape from your painting slowly to avoid tearing the paper. These tapes work best for holding down smaller sheets of paper, which are less likely to warp.

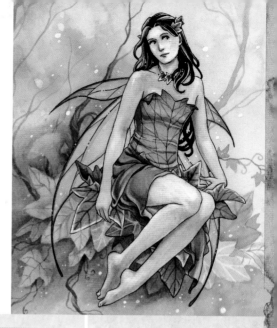

RULE

47

Stretch your paper to keep it flat

Use the technique of stretching paper to ensure that your paper remains flat while painting and when dry. Supplies you will need to start are: a water basin (large bowl or bathtub), gummed paper tape, a wood or masonite drawing board and your watercolour paper. You will need to trim your paper so that it is at least 2.5cm (1in) shorter than the board you will tape it to.

➤ Easily painting wet-in-wet background washes is made possible by stretching the paper and masking out edges of the figure and main leaves.

STEP 6
Immerse your paper in the water, rolling it back and forth for a few seconds (or longer if you are using very heavy paper). Remove it when you feel that the paper has started to absorb water. Be sure not to leave it too long or the paper will start to fall apart.

STEP 7
Lift the paper carefully by the top corners, allowing the excess water to drain off until the only drops are coming from the bottom corners.

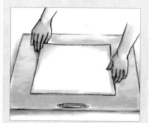

STEP 8
Check that you have the right side of the paper facing up and then centre the paper on the dampened board. Gently press outwards from the centre of the paper to stretch the paper.

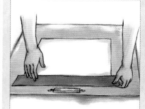

STEP 9
Take the first strip of damp tape and place it half over the edge of the paper and half over the board. Starting at the centre, press down on the tape to make sure it sticks.

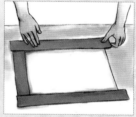

STEP 10
Repeat the last step for all four sides of the watercolour paper. Run your fingers around all edges to make sure the tape is glued down well. You might notice the paper start to buckle in the centre – this is totally normal and supposed to happen.

STEP 11
Leave your paper to dry on a flat surface. Do not prop the board up, as you don't want water to pool to one side. Check after 10 minutes to see if the tape has stuck well. Once your stretched paper and tape are completely dry, you can begin painting your first washes.

Masking

Masking fluid is very useful for the watercolour painter for a number of reasons. Firstly, watercolour paint is transparent, which means you can't paint a light colour over a dark one. Also, there is no such thing as white watercolour paint. These facts mean you have to use the white of the paper for anything in your painting that you want to be bright white. If you're painting very tiny little details, such as sparkles from a fairy's wand, stars in a night sky or spots on a toadstool, it's much easier to preserve the white of the paper with fluid than to paint a dark background right up to the edge of an unmasked white shape. You can also use masking fluid over dry paint if you would like to create crisp edges or lines, such as the veins on a fairy's wings. It is best for painting quick steps so as not to leave the masking fluid on for too long.

RULE 48 — *You don't need to paint every leaf*

Use masking to simplify painting layers of foliage by masking successive layers of colour. Masking is most often used to preserve white of the paper, but you can use it over painted areas as well. To paint foliage, apply successive layers of masking over a series of slightly darker paint colours. Start by masking the lightest and then paint over with a darker colour and then the next darkest colour.

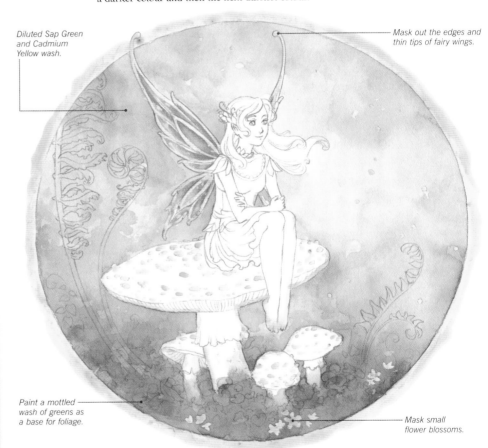

Diluted Sap Green and Cadmium Yellow wash.

Mask out the edges and thin tips of fairy wings.

Paint a mottled wash of greens as a base for foliage.

Mask small flower blossoms.

STEP 1

First, mask any small areas you want to leave white, such as the small flower shapes and the edges of her wings, so you can paint a flat wash over them. Mask the outer edge of the circle to keep a crisp edge on the picture. Paint a wash of light Sap Green mixed with Cadmium Yellow around the mushrooms and flowers. While wet, drop in some more Sap Green for the darker variation.

You will need: ☑ Brush (use an old brush or a rubber-tipped brush to avoid ruining new brushes) ☑ Masking fluid (use coloured masking fluid to make it easier to see your lines on white paper) ☑ Liquid soap (coat your brush hairs with a little soap each time before dipping it in the masking fluid; this will make it easier to wash off the fluid) ☑ Masquepen (a convenient option is a bottle of masking fluid with a fine pen tip)

Step 2

Mask some elongated leaf shapes, dots and curling tendrils. Spatter some masking as well. Paint a mix of Sap Green and Hooker's Green to paint darker areas around the leaves and mushrooms. Paint a layer of Cadmium Red mixed with Burnt Sienna over the mushroom tops.

Step 3

Add some more leaf shapes and spatter with the masking fluid over the same area by holding your brush over the paper and lightly tapping it. Darken the foliage around the masked areas with more Hooker's Green and Sap Green. Paint in ferns and twisting stems in the background. Add shading to the mushroom tops with a mix of Cadmium Red and Alizarin Crimson.

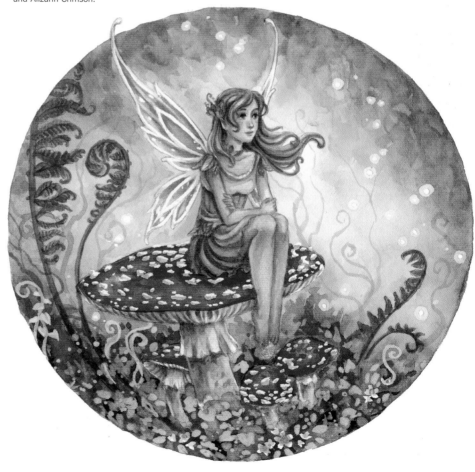

Step 4

Make sure all the paint is dry and remove the masking fluid by rubbing over it with clean fingers or a hard eraser. Don't remove it too soon to avoid smearing the paint or tearing the paper surface.

Step 5

Paint the flower centres with a dot of Cadmium Yellow and the petals with diluted Cadmium Red. Add shadows to the mushroom stems with Burnt Umber mixed with Payne's Gray.

Wet on wet

Painting with wet paint on a wet surface creates some magical effects in watercolour. With spontaneous textures, colours that blend effortlessly together creating soft transitions, and some happy accidents, it's no wonder that watercolour has been used for decades with fantasy and fairy art. Painting wet on wet, allowing the paint to do what it wants, is the most freestyle way of watercolour painting; it gives spontaneous and somewhat unpredictable results – but that is part of the charm and excitement.

RULE

49

Use lots of water

Painting wet onto wet requires the use of watercolour's primary element, which is water. To make it work, your brush should always have water in it, and the paper itself should be wet with either plain water or wet pigment before that wet brush begins its painting. You can wet your paper first by using a spray bottle and misting the surface, or you can use a large brush charged full of water and 'paint' the water onto the paper. All of the effects and techniques used in painting wet on wet require fresh water and fresh wet paint.

STEP 1
Make a light pencil underdrawing of your subject. Start by wetting all of the colours you will use in your painting so that, when you come to add colour to the wet surface of your paper, you don't suddenly find that you haven't got the colour you need. Use a medium-sized brush that will allow some detail but at the same time hold plenty of water, to add clean water to the paper around the fairy.

STEP 2
Charge your brush with Phthalo Blue and begin to drop it onto the wet paper surface. The paint will only go where there is water, leaving the dry paper alone.

Colours used: ☑ Phthalo Blue ☑ Ultramarine Violet ☑ Quinacridone Gold ☑ Quinacridone Rose ☑ Sap Green

BRUSH WETNESS

Wetter than the paper
If your brush is wetter than the paper, it will dilute and lighten your colour. This will also create darkened and crisp edges, or a back run.

Drier than the paper
If your brush is drier than the paper, the pigment you're about to lay down will stay where you put it with soft, feathered edges, instead of spreading and moving throughout the water.

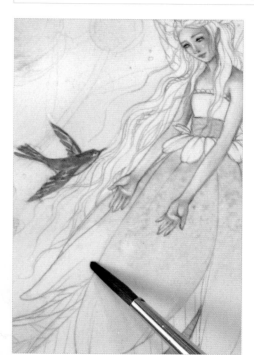

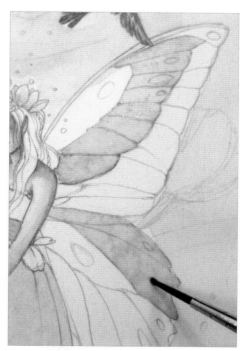

STEP 3

Drop in Quinacridone Rose for the tulips and Quinacridone Gold for the stems, allowing the colours to diffuse together and create soft colour transitions. Wet the skirt's petals and drop in Quinacridone Rose towards the top and middle, letting the pigment diffuse into the white of the paper to create a soft edge.

STEP 4

Return to the background and lay in some Ultramarine Violet around the tulips. While the paint is still very wet, lay down Phthalo Blue along the edge of the Ultramarine Violet, allowing the two colours to merge together, creating a soft wash. Continue down with the Phthalo Blue and introduce the Quinacridone Gold in the same way at the bottom.

STEP 5

Lay Quinacridone Gold onto the wings only where you want wet-on-wet effects to happen. Clean your brush and lightly drop in clean water droplets on top of the freshly laid-in colour. This will create back runs or 'blooms'. Do the same with Sap Green for the leaves at the bottom of the skirt, adding a variegated texture. Switch to a smaller brush for smaller areas.

STEP 6

To create quick colour transitions near the bottom of the painting, rely on the wetness of the paint. Drop in Sap Green pigment, make a few strokes, then grab Quinacridone Gold and drop it in next to the green, allowing them to merge. Lift, return to your Sap Green paint on the palette, and apply to the paper. Continue doing this until you have filled in your space, alternating colours.

STEP 7

Apply water into each tulip bloom and add paint, playing with different wet-on-wet techniques. Pull the paint with the brush, using a sweeping motion to create a feathering effect while following the direction of the petals.

➤ *The wet-on-wet technique allows the background to feel blurred, giving the sense that the fairy is flying.*

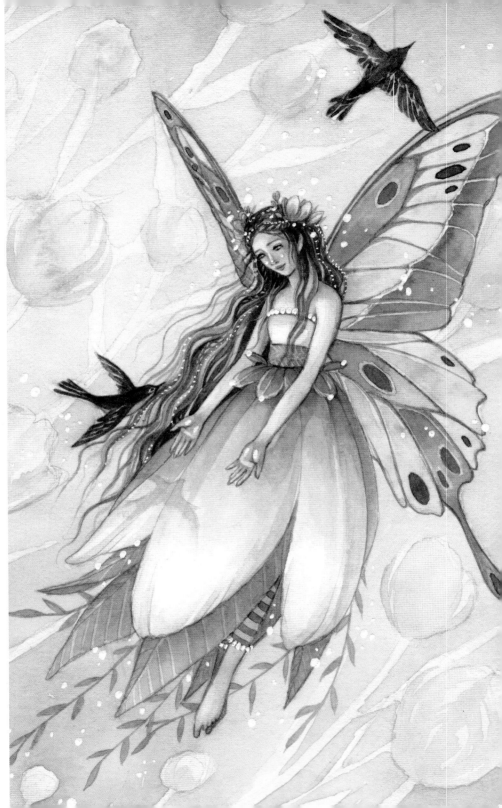

RULE

50

Embrace 'happy accidents'

One of the exciting things about using watercolour wet on wet is when the paint transforms on the paper on its own, creating 'happy accidents'. These can be a nuisance or a delight and can be treated as mistakes or exploited to your advantage. With practice you will be able to judge approximately the right amount of water and paint to add when, but even then you will not entirely be able to control the outcome – and that's a good thing!

One use of wet-on-wet techniques in fairy art is to create soft blurred colours to show motion and depth of field. It will make any garden, sky or forest feel further away, creating a sense of space, or it can create a light, airy presence around a fairy, which is a way to accent her role as a magical being. Wet on wet will also allow blending of rich colour choices to show exciting effects.

COMMON WET-ON-WET TECHNIQUES

GRANULATION
Pigments of the paint separate, creating a rough, mottled texture. Not all colours granulate, but a few that do include: Cobalt Blue (for skies), Raw Umber and Ivory Black (for stones), Sap Green and Quinacridone Gold (for tree bark).

FEATHERING EDGES
Lay down clean water and drop in pigment, allowing it to crawl out into the water, creating soft, blurred edges.

DROPLETS OF COLOUR
Use droplets of a different pigment on top of a colour already laid onto the paper.

DIFFUSED EDGES
Wet the paper and lay down the first colour (here, magenta). While it is still wet, charge your brush with a second colour (here, yellow) and lay it down next to the first, allowing the two to merge naturally, diffusing together.

BLOOMS AND FLORETS
Simply drop in clean droplets of water on top of wet pigment on the paper. The wetter your paper is, the larger and softer the blooms will be. The drier your paper is, the crisper and smaller the blooms will be.

BACK RUNS
This happens when more water pushes the pigment towards the point where wet paper meets bone-dry paper. This will create a bloom-like effect, with very crisp edges where the pigment has gathered.

FIXING MISTAKES

It is a common belief that watercolours cannot be corrected, but in fact, there are several ways of making changes, correcting or modifying parts of a painting.

Paint can be removed by lifting out with a sponge and clean water. Let the paper dry before repainting. For tiny areas, you can use a dampened cotton swab or wet brush, which is also ideal if you want to add highlights or soften over-hard edges.

Sometimes you may find that a white area has been spoiled by small flecks and spatters of paint. You can touch these out with opaque white, but a better method is to remove them by scraping with the flat edge of a cutting or craft knife.

Wet on dry

A classic way to build up the colours in your painting is to apply wet paint to a dry surface that was previously painted. This allows you to create multiple layers of colour, building it up to become richer, and you can bring crisp edges to your fairy and elements within the background, adding a sharper focus for the viewer. Make sure the surface you are painting on is bone dry or the colours will blend together and you'll get a fuzzy line instead of one that is sharp. With this technique, you have a lot of control over how much colour you want and where the paint is going, but wet on dry does have a downfall: too many layers of paint can begin to muddy your painting, so build your colour up slowly.

RULE

51

Bring out the details

Any lines you create with the wet-on-dry technique will be crisp and won't blend with anything unless it's wet. By using a small brush, you can get very crisp and intricate details, such as the veins of leaves and hair strands. You can also paint in lines such as the ridges of tree bark, giving it hard edges and creating a sense of breakage between pieces on the branches. As you build up your colour and details, your painting and fairy will begin to look more three dimensional.

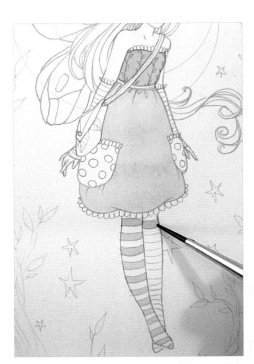

STEP 1

Start by laying in all the base colours on a dry paper surface. Then begin painting tiny details such as the stripes in the fairy's stockings and sleeves. By keeping the brush upright and applying very little pressure, you can keep the application of paint very precise. Be careful not to allow the wet colours to blend together: if necessary, use a smaller brush in these very tight spots.

STEP 2

Begin to lay in the base colours for the branches, not focusing on the details or lines for the bark yet. Bring in more than one colour as you paint, mixing Burnt Umber with some Sap Green directly onto the paper.

Colours used: ☑ Sap Green ☑ Phthalo Blue ☑ Ultramarine Violet ☑ Burnt Umber ☑ Indanthrone Blue ☑ Pyrrole Orange ☑ Winsor Yellow

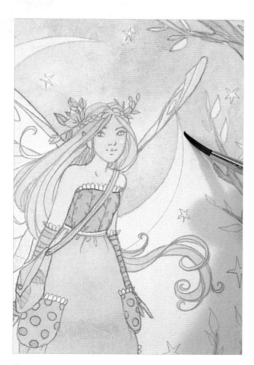

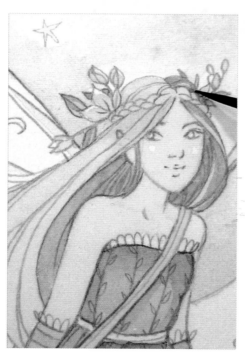

STEP 3

Lay in the background colour wet on dry, but with paint that has been prepared with lots of water so that you can keep going back to it and recharge your brush as you go. Carefully go around the edges of the trees, stars and fairy.

STEP 4

For the fairy's green top, darken Sap Green by adding some Ultramarine Violet, then blend from the top to the bottom (see page 87). Paint the strands of hair that are in shadow with a richer shade of Indanthrone Blue, leaving the highlighted stands untouched.

STEP 5

Begin to paint over the lines drawn for the bark with a darker Burnt Umber. Keep some crisp, and blend out the larger areas to soften the bumps and bends. Create a deep and texture-rich background by laying down Indanthrone Blue over the dry Ultramarine Violet layer. As you paint, drop in clean water drops to give a controlled wet-on-wet texture. Blend out around the stars.

STEP 6

Add in the final details, such as the shadows on the skin, the leaf veins and the darker strands of hair, using smaller brushes. Use the blending technique throughout the face and skin to create a soft look. The smaller the brush, the less water it will hold, so you need to make constant trips to your palette to gather more paint. Don't charge your brush too full of paint at any time, as it will be difficult to get those small details if you have too much paint or water in the bristles.

STEP 7

Define the wings and their shape by creating light and consistent strokes of colour within each section. Slowly build up the colour, repeating the same application but with darker tones and other colours.

STEP 8

Build up the tree branches by painting in darker shades using Indanthrone Blue and Ultramarine Violet with Burnt Umber in the small twists and holes. Draw in the veins on each leaf with Sap Green mixed with Indanthrone Blue and a touch of Pyrrole Orange, and gently outline each star with Pyrrole Orange to help them glow. Finish the painting off by adding fairy sparkles using a white gel pen.

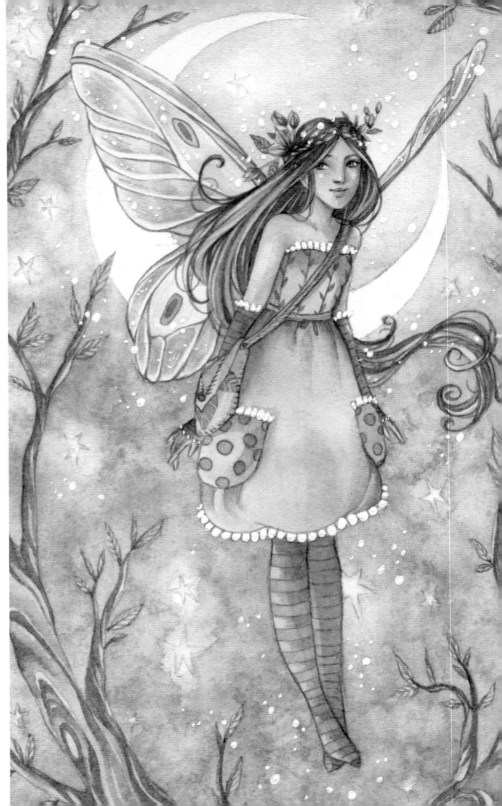

RULE

52

Create smooth transitions by blending

A common technique found in wet on dry is blending, which creates smooth
transitions of colour – for example, in shadows. This technique is great for
clothes, skin and some background elements such as bark, flower petals and
glowing stars. You simply need to move between your paint on the paper, a jar
of water, a paper towel and the paint and paper again. It will take practice, but
keep at it. Start with small areas such as a piece of clothing or hair strands.

STEP 1

Apply a puddle of paint
at the darkest part of your
shadow or where you want
the richest colour. Make
sure it is wet enough that it
won't dry within a minute
or two. Rinse out your
brush. Dab your brush onto
your paper towel; it should
be damp but not dripping.

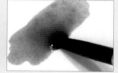

STEP 2

Go back to the puddle and
begin to pull the paint from
the bottom downwards (or
in the direction you want
the shade to disappear
into). Rinse your brush and
dab it on the paper towel.

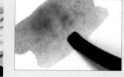

STEP 3

Return to the edge you left
last and pull from it in the
same direction as before.
You should notice the colour
fading. If you pull from the
top of your original puddle,
you will disrupt the blending
and create unwanted
streaks. Rinse and dab
your brush as before.

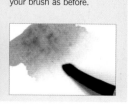

STEP 4

Return one more time,
blending the colour out
at the bottom until there
is no more colour coming
from the brush. Your colour
should vanish into the
colour below it (or into the
white of the paper if there
are no previous layers).

Glazing

Glazing means applying multiple layers of paint to build up the intensity and value of your painting. After each layer has dried, you can apply another layer of a different colour over the top to achieve different hues. It is like painting with coloured tissue paper, laying one colour on top of another to get your desired hues and values – for example, laying down green and then adding a yellow glaze on top to warm and soften it up, or laying a blue layer on top of green to cool it down, making it crisp and intense. This wet-on-dry technique will also achieve the internal glow of your fairy by allowing light to go through all of the glazing layers, down to the original white of the paper. Glazing will be the bulk of your painting, taking the longest time to process.

RULE

53

Make your fairy glow

Begin your painting by putting down the lightest colours first. If you want a warm glow from your fairy, use a watered-down Quinacridone Gold or another warm yellow such as Aureolin Yellow. As you build up your colours, continue with the warmest ones first. Use cooler colours such as blues and violets only in the shadows. Using complementary colours for the shadows helps to add intensity to your glow. The clothes, hair and accessories can be any colour you like, but all should have the same primary light (yellow) and primary shadow (violet).

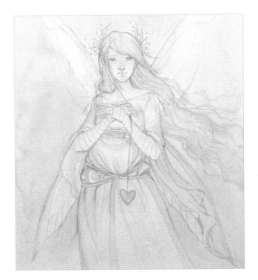

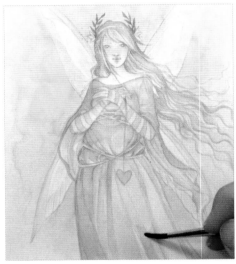

STEP 1

Use your base primary colours (Quinacridone Gold, Quinacridone Rose and Prussian Blue) to mix the secondary colours you need (green, violet, and orange). Using a small flat brush, apply Quinacridone Gold to the background with water drops. Using a no. 3 round brush, apply a watered-down Quinacridone Gold to the skin. Blow dry. Mix Quinacridone Rose and Prussian Blue together to create violet, and apply a light layer where your shadows are. Apply Prussian Blue to the wings and a mix of Prussian Blue and Quinacridone Gold for the hair. Return to the face, using a no. 1 round brush, and apply Quinacridone Rose for the shadows. Leave to dry completely.

STEP 2

Using a no. 3 round brush, mix Quinacridone Rose and a bit of Quinacridone Gold for a skin tone, and apply gently over all of the skin. Next, mix equal parts of Quinacridone Rose and Prussian Blue, then add a hint of Quinacridone Gold to create a grey. Apply a light glaze of grey over all of the clothes except for the arms, filling in only every other stripe. Finally, mix Prussian Blue and Quinacridone Gold with a hint of Quinacridone Rose to create a darker green for the hair, and apply it around the face and in the sections with shadows to intensify its colour.

Colours used: ☑ Quinacridone Gold ☑ Quinacridone Rose ☑ Prussian Blue

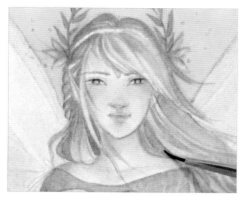

STEP 3

Continue building up the colour with light glazes of darker colours. This will begin to give depth and volume to your fairy and is a step that you should repeat as many times as necessary. Remember not to paint over the highlights – only build up the shadows. Move to smaller brushes as you paint smaller spaces.

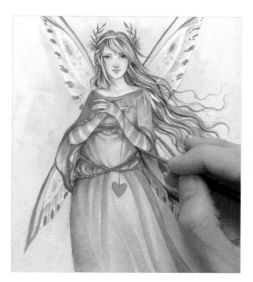

STEP 4

Once the values and hues are near completion, add darker, opaque (more pigment than water) paint to draw crisp attention to details such as the eyes, strands of hair and tight shadow spots. Use a hairdryer to speed up the drying process in between glazes, making sure to keep it at least 15cm (6in) away from the paper on the lowest setting. Painting while the glaze is still wet could create an unwanted muddy colour and take away the desired luminosity.

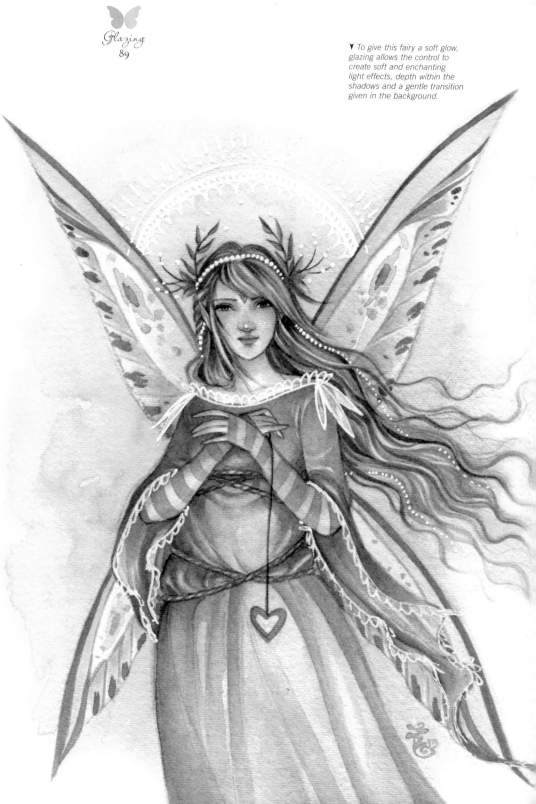

▼ *To give this fairy a soft glow, glazing allows the control to create soft and enchanting light effects, depth within the shadows and a gentle transition given in the background.*

RULE
54

Preserve your highlights

Glazing gives you the time to build up the colour, value and the overall intensity of your fairy. The best way is to work from light to dark. Watercolour painting is about building up colour, not lightening the colours as you would in acrylic or oils. What this means is that you must preserve the white of the paper, or underlying light glaze (usually your first layer), to have any highlights in the end. You do this by avoiding those areas that you want to remain light as you build up, and paint only where you want the colour to get darker or more intense. Know where your light source is coming from before you begin painting.

Colours used: ☑ Indanthrone Blue ☑ Quinacridone Gold ☑ Raw Umber
☑ Alizarin Crimson ☑ Ultramarine Violet

STEP 1
Apply your base layer, making sure you don't paint where you want the white of the paper to remain in the end. Here the daisy, veins of the wings, cheek, pearls and shoulder all have to be left alone.

RULE
55

Restrict your skin-tone palette

Restrict your skin-tone palette to no more than four colours, as this will ensure the colours are consistent and easy to remember, and you won't get overwhelmed with the amount of choices. This will also help prevent the colours from turning muddy. Choose the base colour (the skin's overall tone) by combining two or three colours – usually a yellow and a red. As the skin gets darker, introduce a blue to the palette to help make a browner tone. Each palette should have a highlight (yellow tone), a flesh (red tone) and a shadow (blue tone). First, mix your base colour and apply it all over. Once it is dry, go back in with your flesh colour (red tone) to lightly establish where the shadows will be. You can also lay in the fleshy spots such as the nose, cheeks, forehead and chin. Next, lay in your shadow (blue tone). Slowly build up your skin tone by applying glazes, repeating colours from your restricted palette.

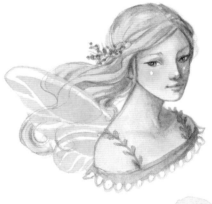

Quinacridone Gold Quinacridone Rose Ultramarine Violet

— FAIR SKIN —

Quinacridone Gold + Quinacridone Rose = base colour
Dilute your mix with a lot of water and test the colour's value on a scrap piece of watercolour paper. There should be more Quinacridone Gold in the mix, with a touch of Quinacridone Rose to warm up the colour. Your red and blue tones will help build up the intensity.

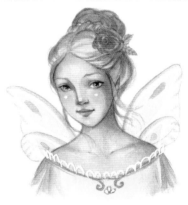

Raw Umber Rose Madder Alizarin Crimson Indanthrone Blue

— ROSY SKIN —

Rose Madder + Raw Umber = base colour
Use Rose Madder with a touch of Raw Umber. Rosy tones are warmer and more pink than yellow. Add Alizarin Crimson in the reddest parts of the skin to help build up the pinker flesh tones. When needed, it can be helpful to add a second yellow, red or blue to help intensify your skin's colour range.

STEP 2

Add your second layer using darker colours, leaving some of the base layer exposed. Here, most of the hair has been filled in, with some strands left untouched. The second layer on the skin leaves those areas on which the light is shining untouched.

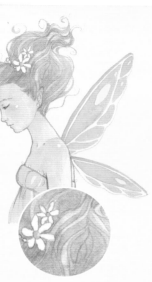

STEP 3

Now you have established the shadows and where the colours need building up. Continue to bring in richer and darker colours in only the shadow areas. By doing so, the areas you have left (the white of the paper and the second layer) will continue to brighten, looking more like highlights.

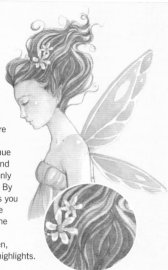

STEP 4

Complete the painting by adding in your final layers, which will be the darkest of all. Intensify the deepest points within the hair, placing some against the first glaze to strengthen the contrast. Do the same within the fabric of the dress and in small areas on the face, such as the nose, ears and eyes.

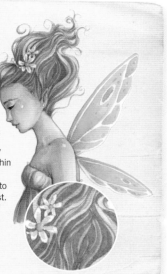

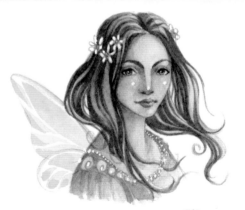

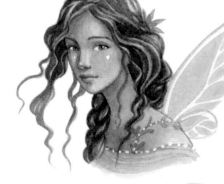

Raw Umber *Alizarin Crimson* *Ultramarine Violet*

Burnt Umber *Cadmium Scarlet* *Indanthrone Blue*

Burnt Umber *Alizarin Crimson* *Indanthrone Blue* *Ultramarine Violet*

OLIVE SKIN

Raw Umber + Alizarin Crimson = base colour
Olive complexions lean more towards yellow or green. Mix your base colour with Raw Umber and a touch of Alizarin Crimson until you see the colour you want on the test swatch. Dilute it down and apply.

MID-BROWN SKIN

Burnt Umber + Indanthrone Blue = base colour
Use Burnt Umber with a touch of Indanthrone Blue to create the brown needed. Mid-brown complexions lean towards yellow, whereas if you add too much Indanthrone Blue it will tend toward green or blue. Note that the red is for flesh only, and not for the base. When mixing browns, rely on oranges with some blues.

DARK SKIN

Burnt Umber + Alizarin Crimson + Indanthrone Blue = base colour
This complexion is a warm brown. Add the red into the base mixture to help deepen your brown, giving it a richer tone. Adding a violet for the shadows will brighten the Burnt Umber, making it feel more like a yellow than a brown.

Adding volume

Volume is the three-dimensional space an object occupies, while a drawing or painting is two-dimensional. You can learn to create a convincing three-dimensional object on flat paper through the use of light and shadow. Try a variety of different shading techniques for the best results. Always start by shading the largest form first and then moving onto details when you begin painting.

RULE

56

Use multiple glazes for the most variety

Use a variety of colour glazes to build up layers on your drawing. You will give volume to the object while creating a luminous watercolour glow that can't be made by mixing colours. Start with a flat base colour, then paint successively darker colours over the top, before finally adding details. See pages 88–91 for more on glazing.

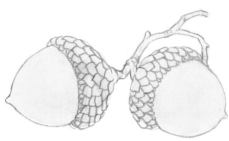

▲ STEP 1
Paint the base colour on the acorns with Yellow Ochre, using a size 4 round brush.

▲ STEP 2
Use Sap Green to glaze colour over the yellow and give shape to the acorns. Paint the darkest tone around the top and bottom edges of the caps and around the edges of the nut and twig. Leave lighter yellow areas for highlights.

▲ STEP 3
Using Burnt Sienna, glaze over the acorn caps and twig. Shade along the edges of the nut, especially at the bottom.

➤ STEP 4
Glaze the nut and twig with Cobalt Blue, making sure to leave the highlight. Add further shadows to the caps with Burnt Sienna and then outline the individual scales with more concentrated Burnt Sienna.

RULE

57 Use complementary colours to create rich shades

Instead of painting shadows with more of the same colour, use your base colour's complementary colour to create depth and shadows. By mixing a complementary colour such as orange and blue, or red and green, it creates a richer muted colour, while painting the blue next to orange creates contrast.

▲ STEP 1

Begin by painting an even base colour for the pumpkins with a mix of Cadmium Orange and Cadmium Yellow. Use Cobalt Blue to paint around the edges and between the leaves, blending out the edges with water.

▲ STEP 2

Use Cadmium Orange to give the pumpkins their round shape. Paint darkest around the stem and along the bottom right edges and then blend the colour toward the centre with clean water. Lightly outline the ridges around the pumpkin. Paint the leaves and stem with a mixture of Sap Green and Cadmium Yellow.

▲ STEP 3

Continue building up shadows with Cadmium Orange and leave to dry. Mix a little bit of Cobalt Blue into Cadmium Orange and use this colour to deepen the shadows on the pumpkins along the edges. Add a little Alizarin Crimson to Sap Green to shade the stem and leaves.

➤ STEP 4

Using less water than before, build up more shadow on the pumpkins with the orange and blue mixture. Outline the ridges and around the stems. Paint veins on the leaves with Sap Green plus Alizarin Crimson. Finally, mix a little Cadmium Orange into Cobalt Blue and paint over the blue between the leaves and around the pumpkins to darken the colour.

RULE

58

Begin by painting the shadows

A technique that is particularly useful for painting skin is painting the shadows first and then glazing colours over them. This gives you a rough guide for painting and allows some of the shadow colour to show through. You will create the same luminous glow of glazing as you build up colours on top of the first shadow layer.

▲ STEP 1

Paint very light shadows on the fairy's face, neck and hair with Dioxazine Purple. Imagine the light source is to her right and paint the deepest shadows at the opposite side. Add a little pale purple between the sections of her wing. Use Cobalt Blue to create shadows on her clothing.

▲ STEP 2

Continue building up darker shadows on her skin, hair and wings with purple. Paint the darkest under her chin and where hair creates shadows on her face and neck. Outline her eyes with darker purple. Darken the folds in her sleeves with Cobalt Blue.

▲ STEP 3

Glaze Burnt Sienna over her hair, then dilute it and paint her skin, using more where the shadows are. With pale Phthalocyanine Blue, paint over the shaded areas on her wings. Then glaze Sap Green over her clothing, eyes and leaves in her hair.

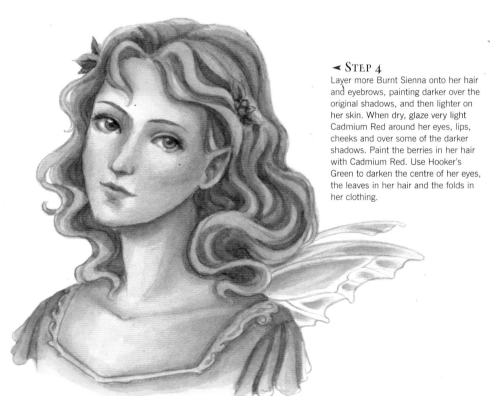

◄ STEP 4

Layer more Burnt Sienna onto her hair and eyebrows, painting darker over the original shadows, and then lighter on her skin. When dry, glaze very light Cadmium Red around her eyes, lips, cheeks and over some of the darker shadows. Paint the berries in her hair with Cadmium Red. Use Hooker's Green to darken the centre of her eyes, the leaves in her hair and the folds in her clothing.

RULE

59

Use dark shadows for contrast

Create the impression of a bright light source by using both bright highlights and deep shadows. You can either build up many layers of colour or use a very concentrated watercolour to paint the shadows. Reserve lighter colours nearest the light source.

▲ STEP 1

Paint the background around the figure and glowing star with Phthalocyanine Blue. Glaze over this with Cobalt Blue closer around the figure.

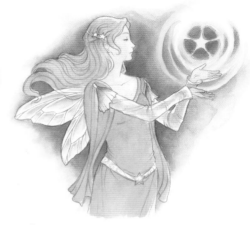

▲ STEP 2

Begin painting the base colours of the figure. Paint her skin with a very diluted mix of Cadmium Yellow and Cadmium Red. Paint her dress with light Cadmium Red. Use Ultramarine Violet to paint light shadows along the centre of her arms, leaving white along the edges. Paint her hair with a mix of Yellow Ochre and Burnt Sienna.

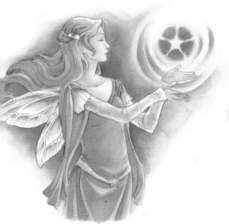

▲ STEP 3

Darken the blue in her wings and shadows on sleeves with diluted Ultramarine Violet. Paint her belt with Yellow Ochre, leaving white highlights on the right side. Darken her hair furthest away from the light source with Yellow Ochre plus Burnt Sienna. Begin adding folds to her dress with Cadmium Red. Paint a medium layer over most of the dress and successive layers in the folds.

▲ STEP 4

Add shadows on her skin with Burnt Sienna mixed with a little Cadmium Red. Paint her lips with red and eyes with Raw Umber. Create the deep folds in her dress with a mix of Alizarin Crimson and Quinacridone Violet. Darken the folds in her sleeves using Ultramarine Violet, plus a little Quinacridone Violet for darker areas. Create deep shadows in her hair and designs on her belt with a mix of Yellow Ochre and Burnt Sienna.

➤ STEP 5

Mix Quinacridone Violet plus Cobalt Blue to add final deep shadows on the dress, away from the light source. Finally, use Raw Umber to add a few deep shadows between strands of hair.

Adding sparkle

Fairies shimmer and sparkle through their wings and the fairy dust they sprinkle about. Watercolours – and specifically the technique of glazing – lend themselves very well to fairy wings, as glazing is all about letting the light through the paint.

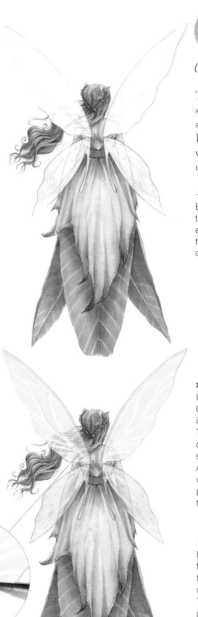

60

Use white space to create translucency

To create a translucent wing, it's important to leave delicate white spaces to divide the wing from the fairy, as there will be colour showing through of whatever lies behind, like the fairy herself. Draw out the wings and map where the veins of the wings are, which would then create sections for colour. The veins will remain untouched by paint throughout the painting process.

◄ STEP 1

Before beginning to paint the wings, knock back the lines that make up the fairy within the wings using a putty eraser. To do this, you can press the putty eraser onto the pencil and lift it up: the eraser will pick up some of the graphite.

► STEP 2

Using a no. 2 round brush and Quinacridone Gold, lay in the initial base colour of the wings. The brush is small enough to be detailed with the corners, but not so small that it can't hold enough paint. As you paint into the wing, leave white space on either side of the pencil marks – these spaces are the veins of the wings.

◄ STEP 3

Return to the colours you used for the fairy's hair, skin and clothes. Water them down, diluting the colours to make them much lighter than before. This will keep the colours transparent, giving the wings a sense of translucency. Add in the colours where the wings overlap the fairy's body. Continue to stay clear of the white spaces you created in Step 2, painting only where it's been previously painted.

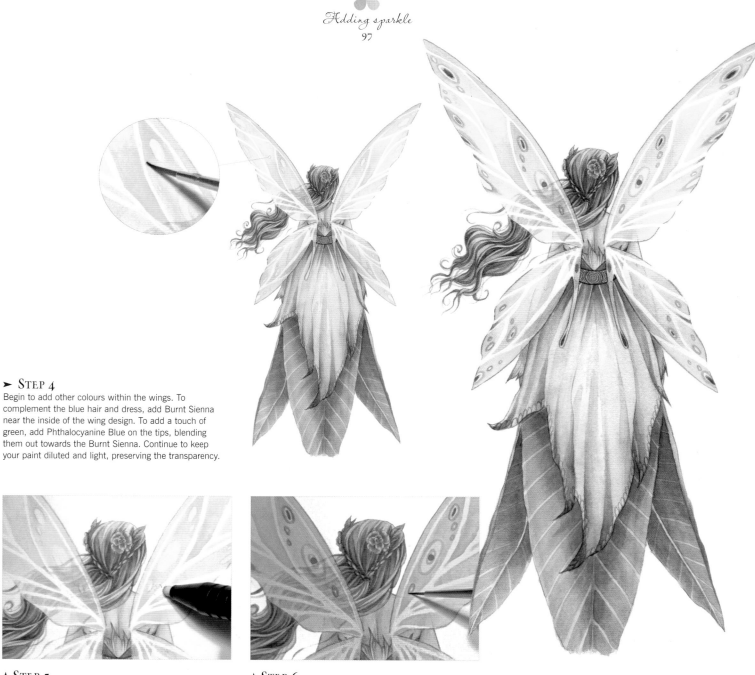

> ## STEP 4
Begin to add other colours within the wings. To complement the blue hair and dress, add Burnt Sienna near the inside of the wing design. To add a touch of green, add Phthalocyanine Blue on the tips, blending them out towards the Burnt Sienna. Continue to keep your paint diluted and light, preserving the transparency.

⌃ STEP 5
Once all is dry, erase your pencil lines. An erasing pencil makes it easier to stay on the pencil lines and less on your paint, which could be lightened by the eraser.

⌃ STEP 6
Add in your final details using a smaller brush, such as a #00. You can intensify some of the colours near the points of any wing section by adding a hint of richer colour and blending it out.

⌃ *The white space left untouched (the vein of the wings) acts as light glare from the delicate material the wings are made from and enhances the colours radiating through the wings by acting as a border, making the wings shine.*

RULE

61

Create a sparkle of fairy dust

All fairy art needs a sprinkling of fairy dust to make it really magical. There are many watercolour techniques you can use to achieve this. Practise them before attempting them on a piece you care about.

─────────── SPATTER ───────────

Prepare enough Phthalocyanine Blue paint to dip a toothbrush into. Dip the toothbrush and gently run your thumb through it, tilting the bristles towards the paper. The more paint in the brush, the bigger the spatter; the less paint, the smaller the spatter. There is little control with this technique but you get far more dots and spats of dots than if you created them with a brush. Go around the larger dots with the same colour, leaving a white ring in between.

─────────── STARS ───────────

Draw in several stars in different sizes around and overlapping your fairy. Paint around each star with Lemon or Winsor Yellow. Once dry, add another outline using Quinacridone Gold – but blend it out away from the stars to give the stars a glow. Fill in the centres of the stars with white gel pen to intensify the yellow.

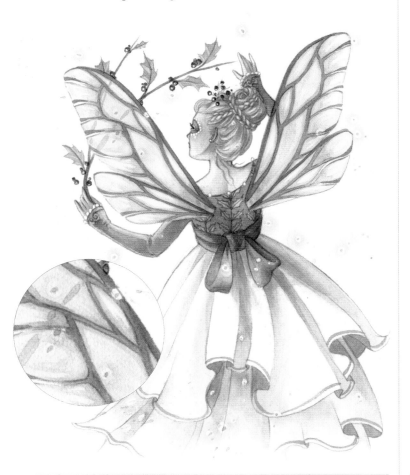

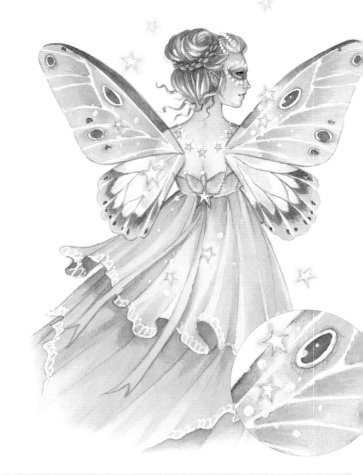

Wing colours: *Phthalocyanine Blue, Phthalocyanine Green, Indanthrone Blue, Quinacridone Gold*

Wing colours: *Pyrrole Orange, Burnt Sienna, Mauve Violet, Raw Umber, Quinacridone Rose*

MIST

Draw in stars and circles of all sizes, creating a continual swirl of these little sparkles around the fairy and her wings. Outline each star and circle with a diluted Phthalocyanine Blue, then with Permanent Rose. Using Winsor Yellow, add paint around the sparkles and the fairy. Leave white space around the sparkles and the fairy, so that the yellow feels like it's carrying the sparkles about. Go back in with a white gel pen and dot each star and circle.

To create a shining twinkle star, draw an 'x' with the white gel pen and lightly paint in some Permanent Rose between each line, blending it out from the centre. Do not paint on the gel pen, but near it.

WISPS

Lightly sketch in where the wisps will be. Using Phthalocyanine Green, fill in each circle. As that dries, mix together in your palette some Phthalocyanine Green with a touch of Winsor Yellow. With this brighter yellow, paint around each green circle and blend it out into a teardrop shape. This gives the wisp a tail and will communicate the direction in which it is flying. Add white gel dots inside each circle and add a few in the tail if desired.

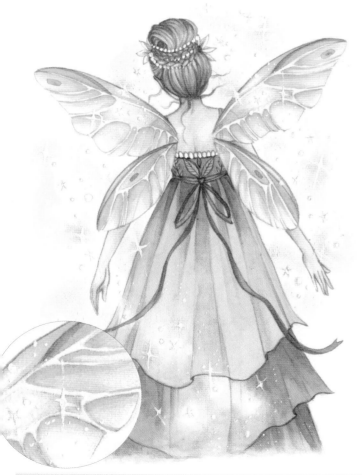

Wing colours: Permanent Rose, Quinacridone Gold, Sap Green

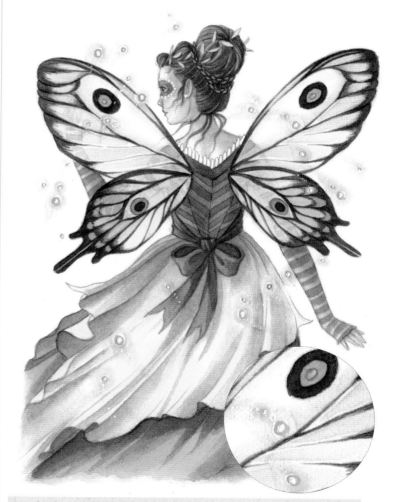

Wing colours: Winsor Yellow, Alizarin Crimson, Quinacridone Rose, Sepia, Black Ivory, Burnt Umber

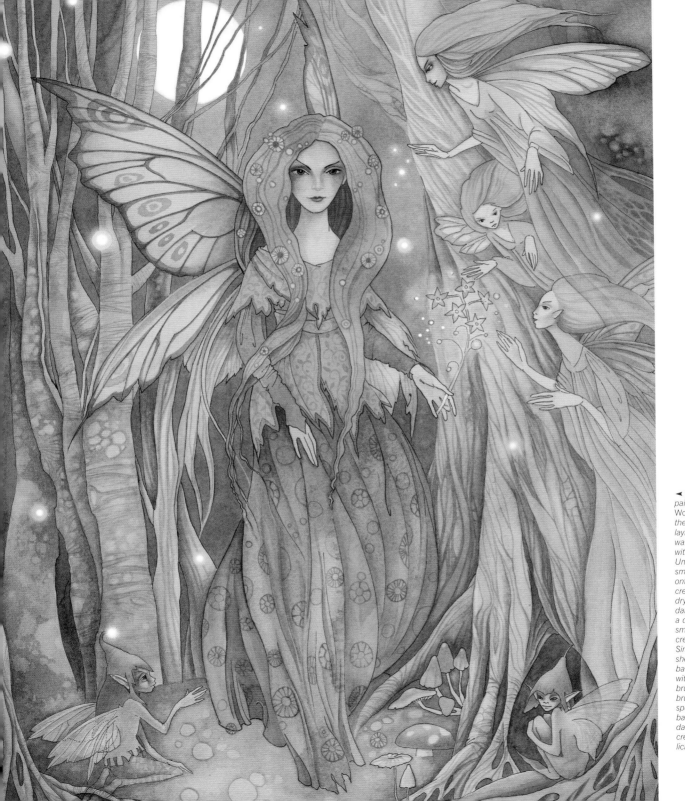

◄ In Suzanne Gyseman's painting Lady of the Woodland, *the textures in the sky were created by first laying down a background wash of French Ultramarine with a tiny touch of Burnt Umber, then dropping in small droplets of clean water onto the damp wash to create paler areas. Once dry, the artist went into the darker areas with the tip of a damp brush and lifted out small spots of pigment to create the speckled effect. Similarly on the tree bark, she lifted spots from the dry base washes of grey-green with the tip of a damp brush. Then she used a fine brush to delineate the pale spots and fissures in the bark with a colour slightly darker than the wash, creating an effect like lichens speckling the bark.*

Creating texture

Texture is another way of making your scenes look more realistic. From rough stone to magical effects around fairies, there many ways of creating textures with watercolour, using both dry and wet techniques.

RULE

62

Paint wet to create abstract effects

Take advantage of the properties of water to create abstract effects. Colours are able to flow and mix together when you paint over wet paint, allowing for many a magical effect.

SPARKLING EFFECTS

STEP 1
Using a large brush, paint your background colour (here, Ultramarine Violet). Use as much colour and as much water as possible. The paint needs to be very wet for the next step.

STEP 2
Sprinkle grains of salt onto the wet paint. Use a salt shaker for large areas or a pinch of salt in your fingers to direct it to smaller areas.

STEP 3
Allow the paint to dry completely before brushing off the salt. You will be left with a pattern of sparkles where the salt grains were.

PAINTING A MOTTLED STONE

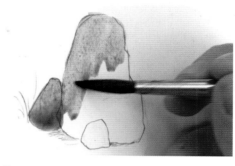

STEP 1
Sketch a group of rounded rocks. Paint over them with a wash of Burnt Umber mixed with a touch of Payne's Gray.

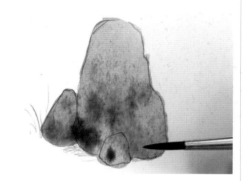

STEP 2
While the base colour is still wet, begin dropping in dots of Burnt Umber and Payne's Gray separately. The colours will spread out and blend together.

STEP 3
Once the paint is dry, use Payne's Gray to add shadows around the bottom and edges.

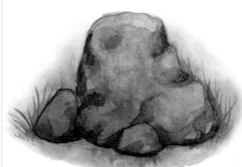

GLOWING SPOTS

STEP 1
Using a large brush, paint a base wash of colour.

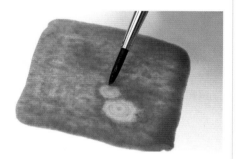

STEP 2
While the paint is still wet, dip a clean brush in rubbing alcohol and drip or lightly touch the tip to the paper. The alcohol will push the pigment away. Using more alcohol will make a larger spot that expands.

STEP 3
Allow the paint to dry, then complete your painting. This technique is a simple way of painting glowing fairy lights or bubbles in water.

PATTERNS

STEP 1
Using a large brush, paint a base wash of Cerulean Blue.

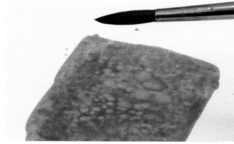

STEP 2
Rinse your brush and load it with clean water. While the paint is still wet, hold it over the colour and lightly tap the brush with your fingers.

STEP 3
As the paint dries, you will have a sparkling, watery pattern that is less pronounced than the salt technique (shown on page 101).

SPATTERING

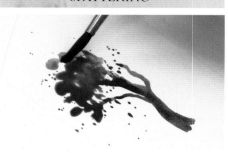

STEP 1
Paint a rough outline of a treetop with Sap Green. Place extra pieces of paper around where you paint to keep the paper underneath clean. Spatter some of the colour around the edges.

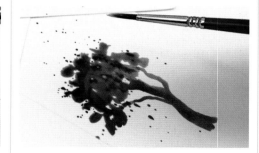

STEP 2
Load your brush with darker Hooker's Green and spatter some onto the wet paint. Then clean your brush and do the same with Cadmium Yellow.

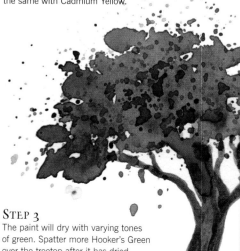

STEP 3
The paint will dry with varying tones of green. Spatter more Hooker's Green over the treetop after it has dried.

RULE

63

Paint dry for rough textures

The technique of painting with a dry or barely wet brush is known as 'drybrush'. Squeeze or blot most of the water out of your brush before picking up paint from the palette. Use the rough, broken lines to create natural textures. You can also use this technique to build up layers of colour for shadows.

ROUGHSTONE

STEP 1
Paint a base wash of Burnt Umber and allow to dry. Paint a second layer of Burnt Umber to give shape to the stone. Leave some light spots and highlights.

STEP 2
Blot your brush on a towel to remove any excess water and pick up a little Burnt Umber with it. Lightly brush it over the paper to make rough marks. You can build up several layers this way or add a darker colour such as Sepia.

GRASS

STEP 1
Paint a base of Sap Green and blend out the top with clean water.

STEP 2
Take a smaller brush, dip it in water, remove the excess water from your brush, and pick up concentrated Sap Green. Use small, vertical strokes to paint blades of grass.

STEP 3
Continue building up layers of Sap Green, and then use Hooker's Green to add darker bits of grass.

BARK

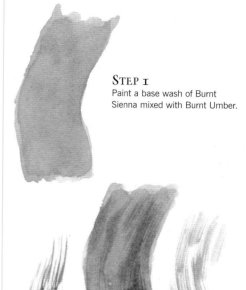

STEP 1
Paint a base wash of Burnt Sienna mixed with Burnt Umber.

STEP 2
Using the drybrush technique again, begin brushing Burnt Umber along the length of the tree.

STEP 3
Use a Sepia or a more concentrated Burnt Umber to drybrush darker, deeper crevices in the bark.

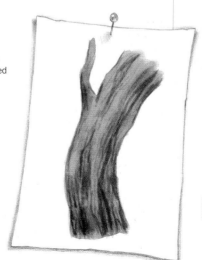

Keep going

One of the most challenging aspects of painting in watercolour is the time it takes to complete the piece. When you begin, you're excited and fired up to work. You draw the fairy out, create the background, chose your palette and start painting. Then you hit the wall of reality: this painting is going to take a lot longer than you thought it would. Don't panic: it's normal to be overwhelmed with the amount of work you just gave yourself. Most of the labour is through glazing and blending, which could mount up to between five and thirty hours for each painting, depending on the size and detail you have laid out. There are things you can do to keep yourself interested, motivated and engaged with your painting. Your environment has a lot to do with how you work, and the way you think about your painting has a big role to play in how you move forward.

RULE 64

You can do this!

Don't let a lack of confidence bring you down in the middle part of your painting. It is easy to get discouraged or frustrated when you can't see anything but unbalanced colours, some faded, some dark, some muddy, and even untouched areas of white paper that make you feel like you'll never reach the end! Remind yourself of what you're trying to accomplish and to give yourself the space and time to do it.

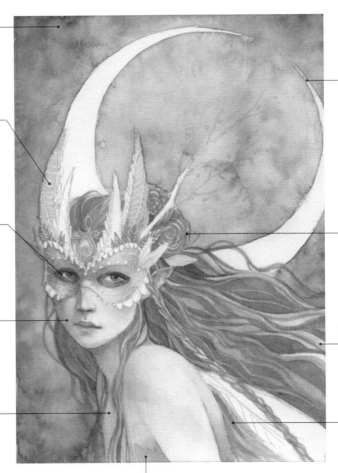

Choosing colours and glazing is a long process. Try to cover all the white space first to alleviate the pressure.

Where's the magic? Sparkles emerging from the owl mask and branches will give more story and visual interest.

Intensify eyes and lips by applying several glazes to make them shine and stand out against the rest.

Skin tone is too dull – to bring light into the skin, more red flesh colour and yellow must be applied.

The foreground blends in with background – intensify it with glazes of richer colours and separate it from the background by making the shadows darker.

The moon needs to glow: the edges where watercolour has gathered and dried must be lifted up gently and softened. The crisp edges draw too much attention and make the moon appear closer than it is.

Even after three glazes, the roses need to be richer – apply more glazes of red, violet and blue.

The hair lacks body and vibrancy. Darken shadows and add more plaits for texture.

Adding hair below the wing makes it appear far too small. The blue needs to be lifted out as much as possible and another wing must be inserted.

The dress is too plain: adding pattern and bolder colours will help draw the eye through the piece.

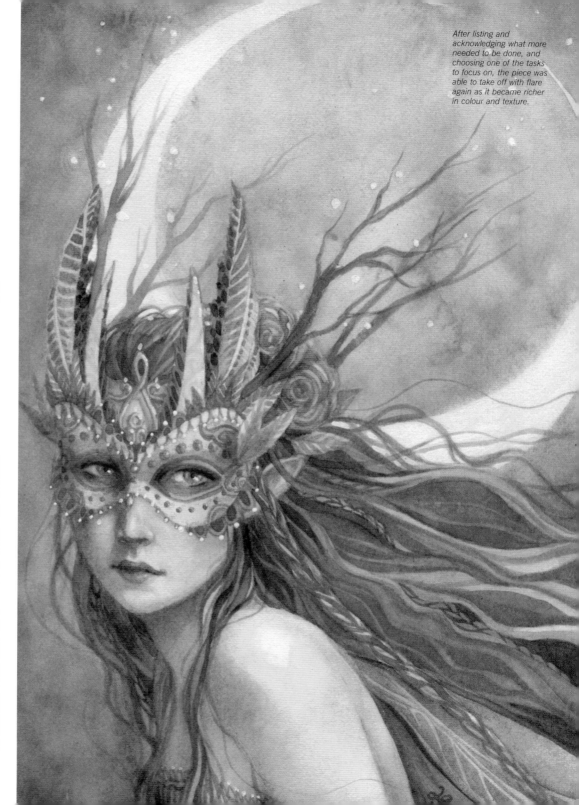

RULE

65

Focus on your goals

Was your goal about technique? Was it about your colour palette? Were you trying to tell a story in one painting? Revisit what motivated the piece in the first place. What kinds of visual references brought upon the idea? Look at your inspiration board and find what fires you up to get back to painting with excitement and gusto. Lay these specific visual references, either from your home, online or from your inspiration board, out in front of you. Keep them around you as you work.

TIP

Look to the past

To see progress, pull out your old artwork that was done a year or three years ago and compare it to the work you are doing now. Acknowledge that you've learned a lot since that old artwork and you're making progress. Never lose sight of where you've come from and understand that to get better, you must make a few ugly paintings, explore scary new techniques, and that it takes time. Every artist must go through these steps to grow. Do not compare your work to others, except to push and motivate yourself to get better. Let their work challenge you to keep trying and to strive for stronger pieces.

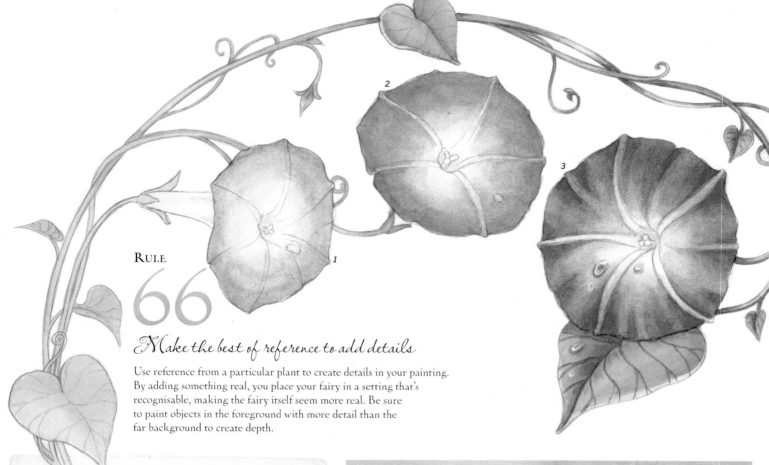

RULE

66

Make the best of reference to add details

Use reference from a particular plant to create details in your painting.
By adding something real, you place your fairy in a setting that's
recognisable, making the fairy itself seem more real. Be sure
to paint objects in the foreground with more detail than the
far background to create depth.

Adding foreground details

After you've decided on the main subject
and composition of your painting, you can
concentrate on creating some smaller details
within the scene. Both foreground and
background details can help tell a story about
the kind of world your fairy lives in. Think
about what plants or animals bring to mind
a particular season or place.

MORNING GLORY

STEP 1
Paint the first wash with a pale diluted Cerulean
Blue and a size 4 round brush. Paint the blue
around the outer edges of the flower and blend
the inner edges with clean water. Leave a white
centre. Switch to a size 2 brush and use
Cadmium Yellow to paint the centre and base
of the blossom. Using Sap Green mixed with
Cadmium Yellow, paint a base layer on the
leaves and vine.

STEP 2
Build up more layers of Cerulean Blue around the
outside of the flower. Avoid the water drop and
paint around the white veins on the blossom, so
that it forms a star shape. Add another layer of
Cadmium Yellow in the centre. With Sap Green,

paint along the centre of the leaf and blend
towards the edge with water. Then do the same
to the other half of the leaf. Darken the vines
and shade where they overlap with another
layer of green.

STEP 3
Use Cobalt Blue to add form to the blossom.
Paint along the edges and dips and ridges in the
petals. Use your smallest brush to lightly outline
the edges of the white star shape, and paint a
thin shadow under the bottom of the water drops.
Then paint the inside of the drop with lighter
Cobalt Blue and leave a white highlight. Mix a
little Cadmium Orange with the yellow and add
a touch to the centre. Finally, use Hooker's Green
to paint darker shadows on the vines and paint
the veins on the leaves.

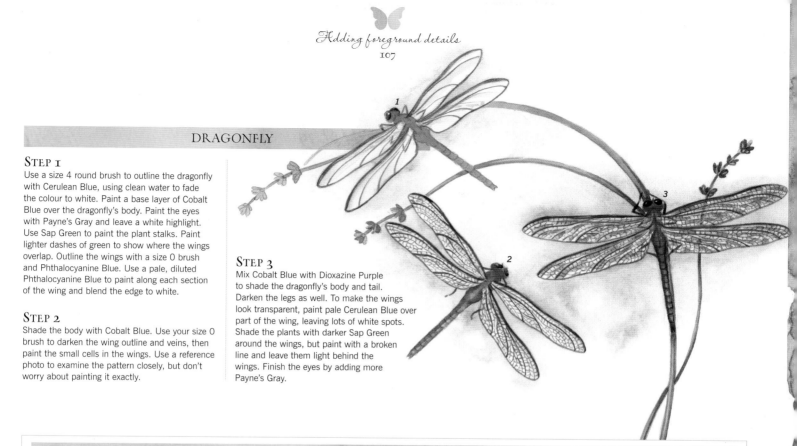

DRAGONFLY

STEP 1
Use a size 4 round brush to outline the dragonfly with Cerulean Blue, using clean water to fade the colour to white. Paint a base layer of Cobalt Blue over the dragonfly's body. Paint the eyes with Payne's Gray and leave a white highlight. Use Sap Green to paint the plant stalks. Paint lighter dashes of green to show where the wings overlap. Outline the wings with a size 0 brush and Phthalocyanine Blue. Use a pale, diluted Phthalocyanine Blue to paint along each section of the wing and blend the edge to white.

STEP 2
Shade the body with Cobalt Blue. Use your size 0 brush to darken the wing outline and veins, then paint the small cells in the wings. Use a reference photo to examine the pattern closely, but don't worry about painting it exactly.

STEP 3
Mix Cobalt Blue with Dioxazine Purple to shade the dragonfly's body and tail. Darken the legs as well. To make the wings look transparent, paint pale Cerulean Blue over part of the wing, leaving lots of white spots. Shade the plants with darker Sap Green around the wings, but paint with a broken line and leave them light behind the wings. Finish the eyes by adding more Payne's Gray.

TOADSTOOL

STEP 1
With a size 4 round brush, begin by painting a light Sap Green around the edge of the toadstool and over the moss at the base. Use clean water to fade the edge of the green into the paper. Mix Burnt Sienna and Raw Umber, and add a pale shadow to the toadstool stem and underside. Paint from the top edge of the gills and blend the colour away. Use Raw Sienna on the top of the toadstool, painting darkest in the centre and letting it fade to white.

STEP 2
Build the colour on the tops of the toadstools with more Raw Sienna, making them darkest at the tops. Drop in more Raw Sienna while the paint is still wet. Shade the stem and underside with Burnt Sienna plus Raw Umber. Switch to a smaller size 2 brush to paint darker shadows between the toadstool gills. Add variation to the green moss with Sap Green. Paint shadows by dabbing spots of darker green and leaving highlights.

STEP 3
Using Burnt Sienna with a size 4 brush, paint along the top edge of the toadstool and continue downwards, painting circle outlines. Then quickly blend all the paint together, leaving lighter spots. You can drop in more colour in between until it's dark enough. Use a small brush to make lines on the small toadstool top. Deepen the shadows between the gills with Raw Umber mixed with a touch of Payne's Gray. Use the same mix to shade the stem. Use short strokes to give texture to the stem. Add deeper shadows to the moss and grass with Hooker's Green. Finally, use a touch of white gouache to make a highlight on the small toadstool and spots on the toadstool.

Adding background details

Details in the background should be less defined than in the foreground. As the landscape becomes further away, the atmosphere affects the colour and clarity. Hills and mountains furthest away appear lighter and take on a blue colour like the sky. This is known as 'atmospheric perspective'.

BACKGROUND FOLIAGE

STEP 1
Sketch a tree branch, and draw a few leaves on it. Paint a light wash of Cadmium Yellow mixed with Sap Green over everything.

RULE

67 Don't paint every detail!

Objects that are closer to us are seen in more detail than those far away. You can use this principle in painting to create depth and speed up your painting process. Instead of painting a faraway landscape in the same amount of detail as the foreground, paint a suggestion of the background along with a detailed foreground.

DISTANT FOREST

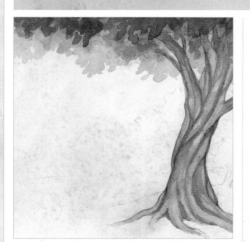

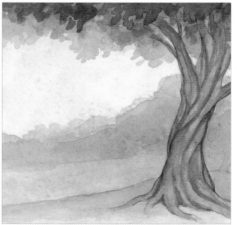

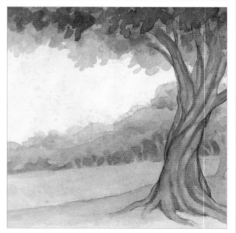

STEP 1
Paint a background wash in very light Viridian Green. Darken the foreground tree with Viridian Green and then add details with Hooker's Green.

STEP 2
Glaze Sap Green over the foreground tree. Mix Viridian Green and Sap Green to paint over the ground and forest in the background. Paint vague outline of trees and don't worry about details.

STEP 3
Using the same green mix, paint shadows under the trees in the background. Paint in sections and leave small spaces between for branches and trunks. Paint some of the treetops darker to create a layered effect.

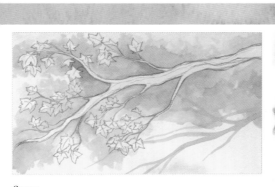

Step 2
Using a size 2 brush, paint diluted Sap Green around the branch and between the leaves. Fade the colour out furthest from the branch and dab your brush randomly over the background for variations in colour. Paint another branch near the bottom in green.

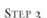

Step 3
Mix Viridian Green and Hooker's Green. Darken the background branch and build up a few layers of leaf-shaped strokes. Add more Hooker's Green to paint the last layer of darker leaves. Paint the foreground leaves with a mix of Sap Green and Cadmium Yellow and the branch with Burnt Umber.

HILLS AND MOUNTAINS

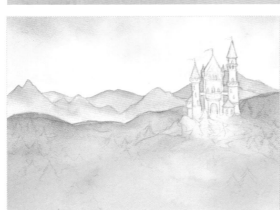

Step 1
Wet the paper where the sky will be. While the paper is still wet, use Phthalocyanine Blue mixed with Cobalt Blue to paint the upper sky. Lightly paint the mountains with pale Dioxazine Purple. Paint the tops of the hills with a mix of Cobalt Blue and Sap Green; while this area is still wet, blend the colour toward the bottom with Sap Green.

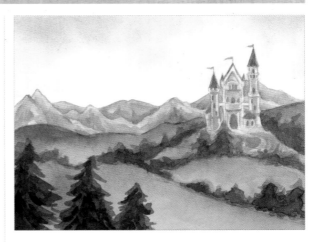

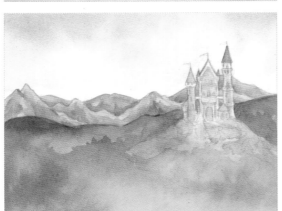

Step 2
Mix Dioxazine Purple with a little Sap Green, and add shadows to the mountains. Paint the lower hills with Sap Green towards the bottom and Sap Green plus Cobalt Blue near the top. While the background is wet, use the darker green mix to paint trees along the edges of the hills. Add light shadows on the castle using pale Payne's Gray.

Step 3
Mix Dioxazine Purple with a little Sap Green and add shadows to the mountains. Paint the lower hills with Sap Green towards the bottom and Sap Green plus Cobalt Blue near the top. While the background is wet, use the darker green mix to paint trees along the edges of the hills. Add light shadows on the castle using pale Payne's Gray. Paint the trees in the far background with Sap Green plus Cobalt Blue. Make the trees closer to the foreground darker. Add shadows to the foremost trees with Hooker's Green. Paint darker shadows on the castle with light Payne's Gray. Then paint in the windows, doors and roofs.

Finishing touches

When the end is near and everything has come together, you may find some details or colours that you intended to be there are lacking or missing. Or you may think there is more that can be done, but are not sure how to go about it. Finishing touches are just that – little bits of colour, texture, pattern or enhancements onto your painting. They shouldn't take a lot of time to add, nor should they take over your painting. Be choosy about what you want to enhance or make clearer using these mediums. Does the dress need some fancy flare? Or can the wings be pushed just a little more to make them stand out? What about the shadows – could they be richer in colour?

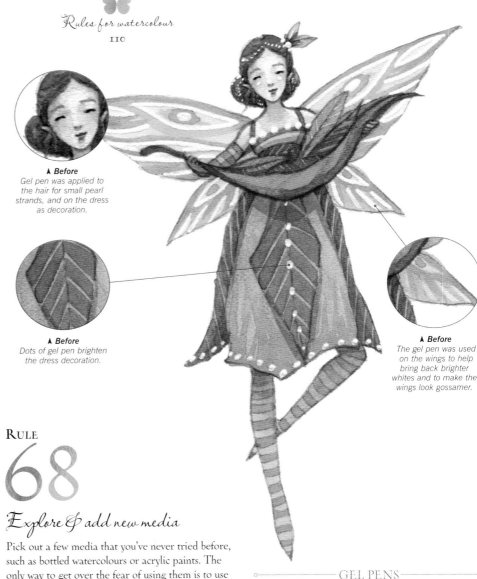

▲ *Before*
Gel pen was applied to the hair for small pearl strands, and on the dress as decoration.

▲ *Before*
Dots of gel pen brighten the dress decoration.

▲ *Before*
The gel pen was used on the wings to help bring back brighter whites and to make the wings look gossamer.

RULE

68

Explore & add new media

Pick out a few media that you've never tried before, such as bottled watercolours or acrylic paints. The only way to get over the fear of using them is to use them. Play with their possibilities on a separate sheet of paper before applying them to your fairy painting. What medium is transparent? Which one hides the colour underneath? Mixed media can greatly help your painting and your fairy stand out. Here is a small list of media that work well with watercolour, but don't stop with just these. Search your studio or an art store for other possibilities.

GEL PENS

White gel pens can make a world of a difference when whites need to be brought back or when little details such as pearls or sparkles are needed. Gel pens are opaque, so when applied they cover the colour up entirely. The white can be blended out or washed away using water. Add the gel pen at the very end, because any painting over it could result in some soft white haze you didn't intend or you could wash it away entirely. Do not overuse the gel pen, as its dot texture could distract from the painting.

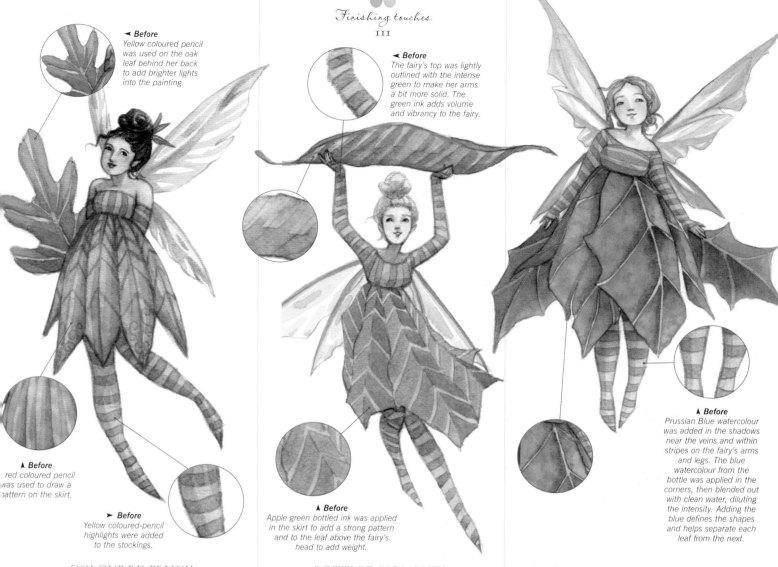

◄ Before
Yellow coloured pencil was used on the oak leaf behind her back to add brighter lights into the painting.

◄ Before
The fairy's top was lightly outlined with the intense green to make her arms a bit more solid. The green ink adds volume and vibrancy to the fairy.

▲ Before
red coloured pencil was used to draw a pattern on the skirt.

➤ Before
Yellow coloured-pencil highlights were added to the stockings.

▲ Before
Apple green bottled ink was applied in the skirt to add a strong pattern and to the leaf above the fairy's head to add weight.

▲ Before
Prussian Blue watercolour was added in the shadows near the veins and within stripes on the fairy's arms and legs. The blue watercolour from the bottle was applied in the corners, then blended out with clean water, diluting the intensity. Adding the blue defines the shapes and helps separate each leaf from the next.

COLOURED PENCIL

Coloured pencil gives you a lot of control in colour intensity and detail. The key to using coloured pencil is the amount of pressure you apply. If you use heavy pressure, your colour will be intense; if you let up and colour lightly, the watercolour underneath will show through, only slightly changing the colour. Sharp coloured pencils can also be used to add details such as patterns and hair strands.

BOTTLED PIGMENTS

Bottled inks and pigments will instantly intensify your colours. They are permanent, which means you won't be able to lift the colour out of your paper as you would watercolour, but they can be watered down and glazed like watercolour. They are also quite saturated applied straight from the bottle, so keep in mind that the colour you're painting over will change dramatically.

BOTTLED WATERCOLOUR

Bottled watercolour paint provides all the qualities of watercolour in pre-mixed liquid form. It is highly concentrated, so to paint straight out of the bottle would give you extremely intense colour. When you add water, you can thin it out, add texture such as water drops and blend it as you would watercolours.
Bottled watercolours are an excellent choice for intensifying shadows or painting large areas of paper. To paint a large area or make a wash, use the dropper attached to the lid, add a few drops of pigment into a small glass of water and apply.

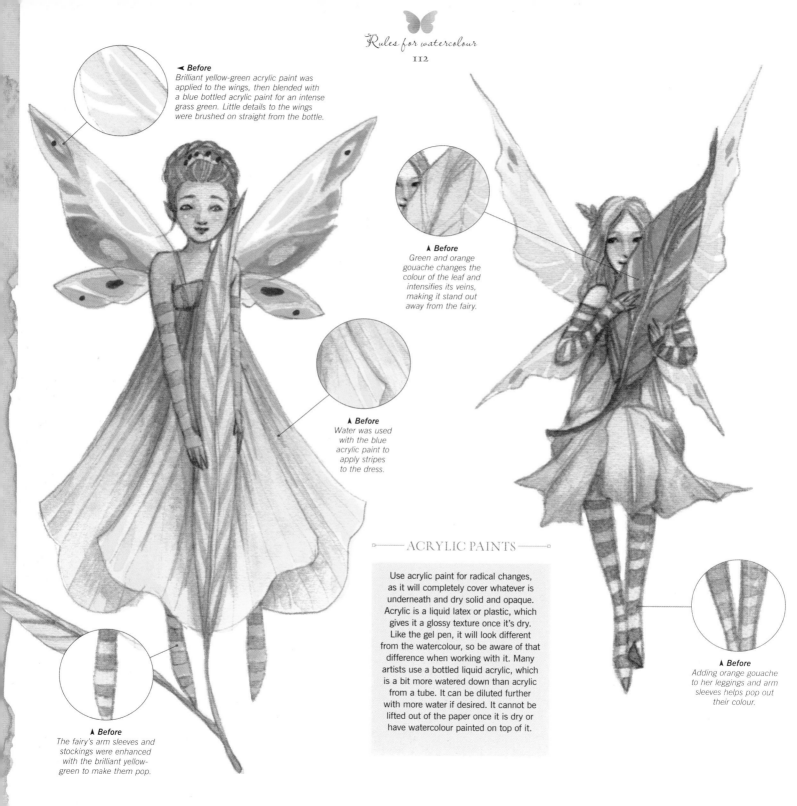

◄ Before
Brilliant yellow-green acrylic paint was applied to the wings, then blended with a blue bottled acrylic paint for an intense grass green. Little details to the wings were brushed on straight from the bottle.

▲ Before
Green and orange gouache changes the colour of the leaf and intensifies its veins, making it stand out away from the fairy.

▲ Before
Water was used with the blue acrylic paint to apply stripes to the dress.

▲ Before
Adding orange gouache to her leggings and arm sleeves helps pop out their colour.

▲ Before
The fairy's arm sleeves and stockings were enhanced with the brilliant yellow-green to make them pop.

ACRYLIC PAINTS

Use acrylic paint for radical changes, as it will completely cover whatever is underneath and dry solid and opaque. Acrylic is a liquid latex or plastic, which gives it a glossy texture once it's dry. Like the gel pen, it will look different from the watercolour, so be aware of that difference when working with it. Many artists use a bottled liquid acrylic, which is a bit more watered down than acrylic from a tube. It can be diluted further with more water if desired. It cannot be lifted out of the paper once it is dry or have watercolour painted on top of it.

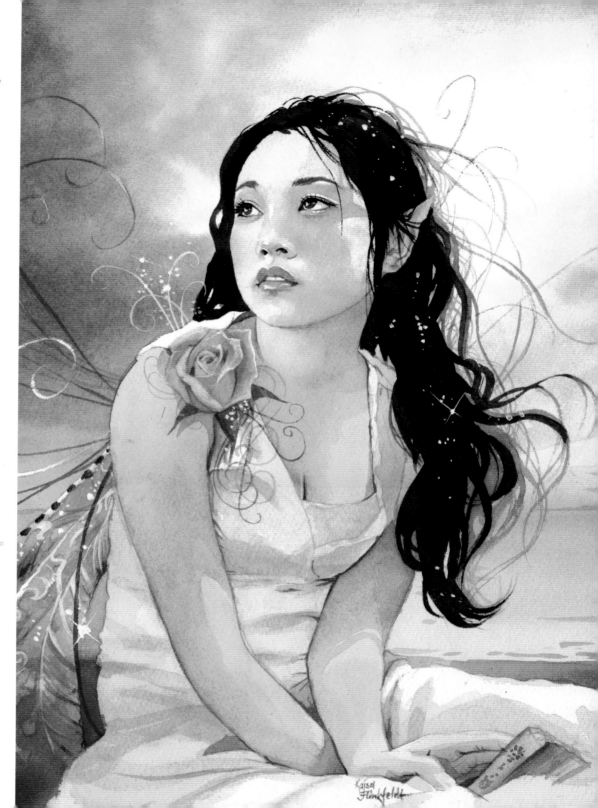

➤ *In* Golden Fairy, *Kajsa Flinkfeldt uses white gouache to add the sparkles in the hair and background and highlights the face and wing.*

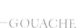

GOUACHE

Gouache is a thicker and more opaque watercolour option; the consistency is similar to watercolour straight out of the tube. Gouache is frequently used with watercolours because it behaves in a similar way. Once it is dry on your palette, you can rewet it, mix it with watercolours and lift it out of the paper. It is great for intensifying or slightly changing a colour. It is not 100 percent opaque, so it won't cover your watercolour entirely and it tends to have a chalky appearance, which doesn't let light through like watercolour.

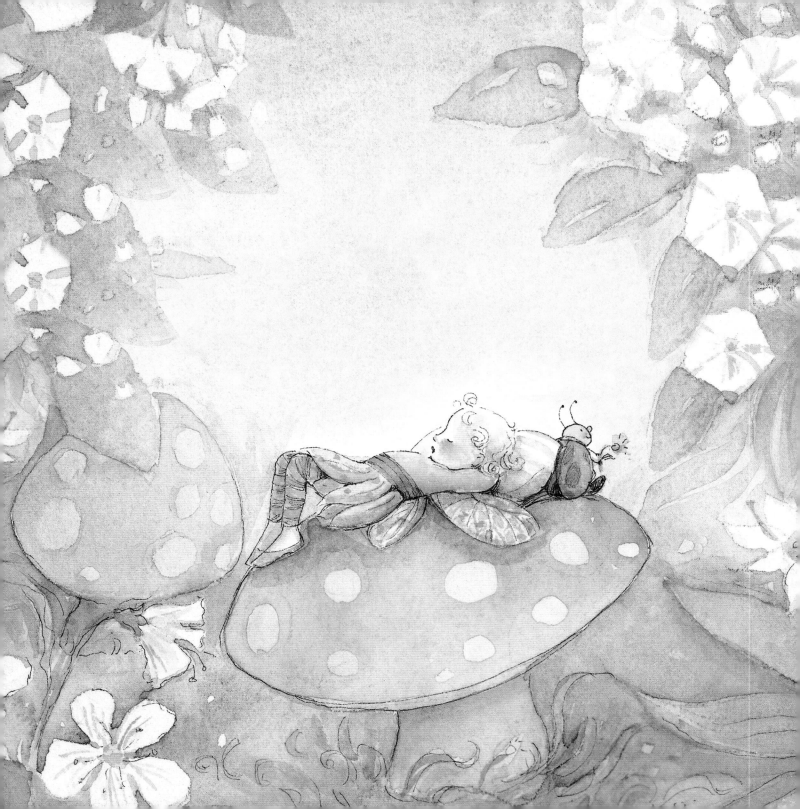

3 Other artists' rules

Learn from internationally renowned fairy artists such as Amy Brown, Meredith Dillman, Julia Helen Jeffrey, Becky Kelly, James Browne and Paulina Cassidy, as they share their working practices and rules for watercolour painting. Let them teach you through their own experiences and years of expertise, and be inspired by their fairy worlds!

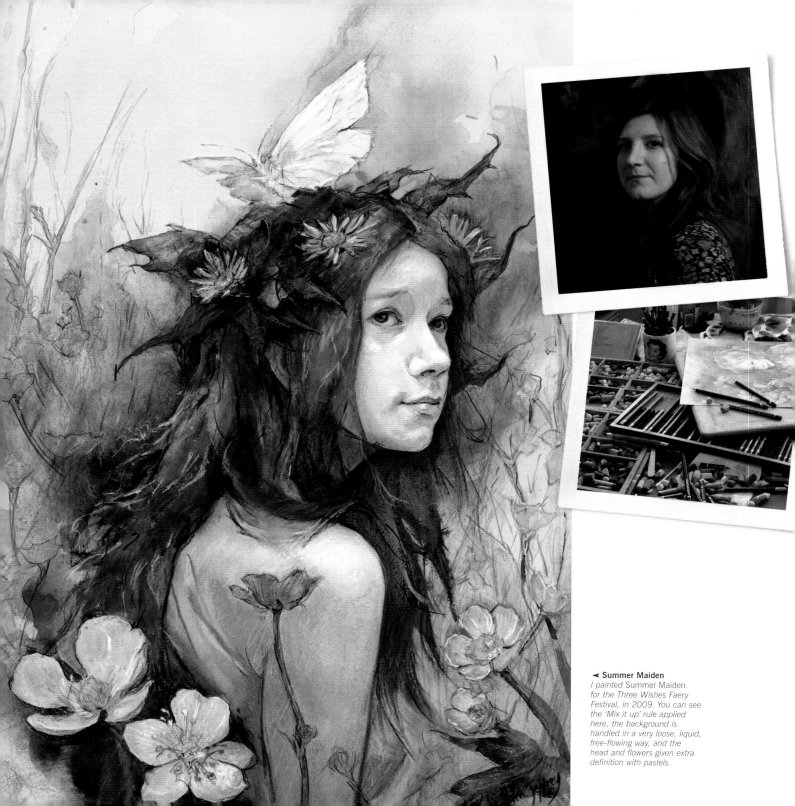

◄ **Summer Maiden**
*I painted Summer Maiden
for the Three Wishes Faery
Festival, in 2009. You can see
the 'Mix it up' rule applied
here, the background is
handled in a very loose, liquid,
free-flowing way, and the
head and flowers given extra
definition with pastels.*

Julia Helen Jeffrey

Julia Helen Jeffrey is a Scottish artist and illustrator. Her work appears on book covers and in novels, short story collections and fantasy journals, illustrating the work of celebrated authors such as Charles de Lint and Ari Berk. She has also just released her first tarot deck, *Tarot of the Hidden Realm*.

For me, watercolour is the perfect medium for fairy art, in that it is highly unpredictable and extremely difficult to control, but can mysteriously provide moments of free-flowing beauty that could never have been planned!

Although I've now worked almost exclusively in watercolour for nearly a decade, I don't really consider myself a watercolour painter. I trained in oils, which could hardly be a more different medium, and I still think of myself as an oil painter. I love the solidity of form that can be achieved with oils, their heavy texture, and the subtle shifts of tone and colour – but somehow, that approach just doesn't work for me, with fairy and fantasy art.

For me, at the heart of fairy art is a tension between what is real and tangible, and what is elusive and ethereal. In my own work, I mainly rely on drawing to convey the reality of the subject: to make characters convincing, to portray individuality and expression and to provide telling details that can give a sense of setting and context. But I look to watercolour for glowing effects of light and colour, a shimmering sense of mood and movement and hints of texture, which can suggest foliage or water, without labouring the point or losing freshness and immediacy.

Watercolour is a very sensual medium; so much of the success or failure of a painting is in the physical feel of doing it, which means that finding the particular brushes, paints and painting surface that feel good to you is vital. Inevitably, this can take a bit of time and trial and error. These days, I wouldn't be parted from my pure squirrel mop brushes, or my Winsor & Newton Artists Colour tube paint – both absolute fairy watercolour essentials for me! So explore and enjoy, find the tools, and feel the flow that creates magic for you!

RULE

69

Mix it up

Don't be afraid to combine watercolour with other materials. For me, watercolour is wonderful for loose, broad, atmospheric passages of painting – but very difficult and restrictive for areas that need precise definition. Try using watercolour pencils and pastels over watercolour. Experiment and be bold!

RULE

70

Don't overwork things

Overworking watercolour is a surefire way to kill it stone dead! For broad areas, plan it out, lay the paint down, adjust it maybe once or twice – and if it's not working, start afresh.

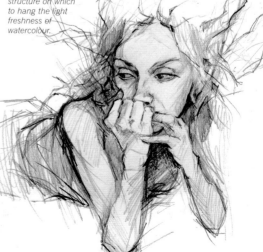

➤ **Summer Reverie**
I use drawing to ground my work – to give it a solid structure on which to hang the light freshness of watercolour.

Becky Kelly

Growing up in West Virginia, Becky's parents encouraged her love of art. After graduating from the Columbus College of Art and Design, Becky accepted a job with Hallmark Cards. As a freelance artist, her artwork appears on cards, books and gift products. Birds, deer and a friendly chipmunk or two surround her sunlit art studio.

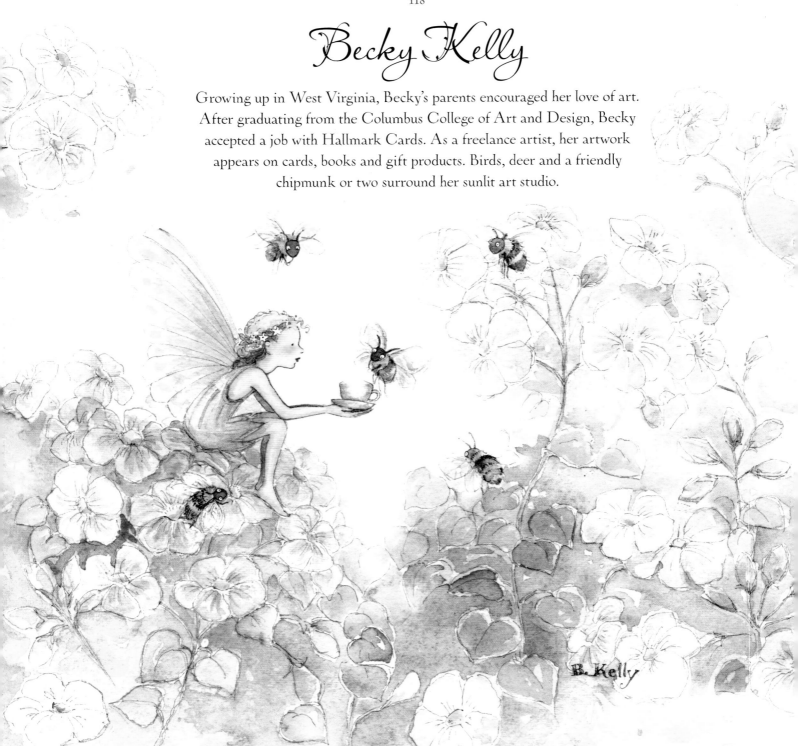

B. Kelly

◄ Bumble Bee Tea
The bees and flowers all direct the eye toward the cup of tea, which stands out against the plain white background.

As a child, there was never a question: my gift was unmistakably art. It was all I thought about, dreamed of or pondered. When I became an adult, I felt it was important to create art that touched the heart, evoked a sense of emotion, and helped people connect through images. As C. S. Lewis says in *The Four Loves*, 'Friendship is unnecessary, like philosophy, like art.... It has no survival value; rather it is one of those things which give value to survival.' I've adopted his words as my personal philosophy. When I begin a painting, I think about the message I want to inspire. Next, I gather research around me, like photos or pictures of inspirational children. It is as if my studio becomes a giant Pinterest board. The illustration story comes together first in my mind, much like a daydream. In my imagination, I can see the fairy in an environment. I search for the best angle, lighting and body language to convey the message. Then, I start to sketch and the visual story begins to write itself. I've found that so much can be said without words.

I also think about how I can add elements that will communicate feeling. Sometimes it's the addition of ladybirds that help give an illustration the feeling of contentment, like the joy that comes from quietly sitting with a favourite pet. Or sometimes it's simply the body language or perspective, like peeking through the leaves, that evokes the spirit of the piece.

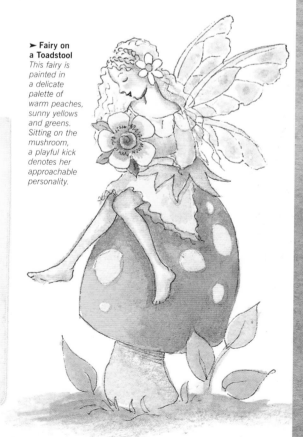

➤ Fairy on a Toadstool
This fairy is painted in a delicate palette of warm peaches, sunny yellows and greens. Sitting on the mushroom, a playful kick denotes her approachable personality.

RULE

71

Use colour to create atmosphere

I discovered early on that fairy wings should have a lovely gossamer, ethereal quality. I've also found that colour temperature can further enhance a scene, providing warmth or sense of peace.

RULE

72

Direct the eye to the subject

If I keep areas behind the subject simple, then the eye goes straight to the main point. I believe contrast should be carefully placed where I want the observer to look first. In this way, I arrange elements in the design to point to important aspects of the story I want them to discover.

James Browne

James Browne has been creating whimsical fairy art for over 20 years, and he has always put his heart into his work in a way that the viewer can experience a journey of imagination and the joy of discovery. Imagination is truly a gift.

Watercolour is one amazing medium to work with. It is the element of transparency and the lovely subtleness in colour and tonality that I like most about it. You are able to see your original drawing foundation throughout most of the painting process, which to me is a good thing as I rely a lot on my drawing. I find that watercolour is a more direct way to colour your drawing. That is where the transparent quality of watercolour comes in, along with its unique colour subtleties. Your drawing is part of your painting, and in most watercolour paintings this is evident. Another wonderful thing about watercolours is that you can paint one layer over another layer, and with each passing layer you can still see the underlayers. You can achieve colour change in tonality, hue and saturation using this layering technique or you can pre-mix a desired colour right on your palette.

The papers I like to use are Arches 300gsm (140lb) hot- and cold-pressed papers, preferably in watercolour block form. My favourite watercolour paints are Winsor & Newton tubes. My brushes of choice are the Robert Simmons White Sable synthetic brushes. I like to work on many different palettes and palette cups.

As far as the subject of fairy is concerned, it is in fairyland where my imagination soars the most and the boundaries are limitless. I had a very fruitful upbringing filled with lots of books, plenty of adventures in the nearby forests and streams and no TV. It was in my early years that my imagination grew strong, and it is in my life as an artist that I'm able to express my imagination through my paintings. I'm still that little boy inside discovering fairyland.

➤ The Monarch
This double portrait was a private commission where I composed a painting using photo reference for the children and butterfly, and the rest was created using my imagination.

RULE

73

Tea and brush water don't mix

Whenever you're painting with watercolours, always keep whatever it is that you're drinking away from your cup of water that you mix paint with. There have been a number of times that I have dipped my brush into a hot cup of tea or coffee and applied it to my painting, especially when pulling an all-nighter.

RULE

74

Art is like a relationship

You need to get to know the subject in which you are painting, you have to try to relate to it, you need to put your heart into it, you need to spend time with it and you need to let it breathe when you struggle with it.

➤ **Winter Refuge**
This painting was inspired while watching the snow fall one evening. I had an image in my mind of a great snow owl being shelter for the wee folk.

Paulina Cassidy

Born in Ontario, Canada, Paulina finds solace in creating and sharing her magical brew of whimsy. Paulina works from her private studio in Chattanooga, Tennessee, where she draws, paints, writes and composes music. Her fanciful designs are loved and collected worldwide.

I create my work mainly using watercolour, ink and watercolour pencils. They're a synergy, dancing together, as the piece evolves. My first love is line art; working with shadow and light using organic, fine lines, and combining this with watercolour, layer by layer. I build the piece slowly and subtly, beginning with pencil lines and a light base of colour. I prefer to use an HB pencil on a smooth, hot-press watercolour paper. The pencil marks mix well with ink lines, as they help tell the story of the unfolding of the piece, and I erase only the pencil lines that don't work aesthetically. I build the overlays of colour, checking that the tone remains balanced throughout. I work intuitively; this is the part we all have that is tuned-in and connected to the endless stream of creative energy. When we're in touch with our intuition, we become more sensitive to our inner vision, and this process strengthens over time. This inner vision is connected to the many dimensions of space around us, which include elementals and other beings. Each character that I draw already exists in another realm. Their individual personalities influence their portrayal, so I feel like I'm working with a 'fae-de-force' of sorts. It's a matter of opening up to their world, welcoming their presence and trusting their messages.

Atmospheric music is mainly played in the studio, which helps open that floodgate of inspiration. It helps my mind wander and stop the 'chatter' while creating. I prefer to let the piece go where it chooses to go, which more readily allows ideas and images to emerge.

My cats are usually in the room with me while I work. I love having their energy around during the creative process. Animals are such pure and loving and wise souls, and they lend a great deal of magic.

➤ O'er Sacred Ground
Flying silently over the ground, this fairy family is trailing sacred incense through the forest in honour of the ancient elementals. I worked this one mainly using pen and ink, and layered muted watercolours to slowly build up tone. The final piece is 28 x 35.5cm (11 x 14in).

◄ In Search of Peter Pan
An homage to the music of Kate Bush, I created this one as a pencil sketch, and built it up somewhat quickly with watercolour and pen/ink. The piece itself is around 18 x 25.5cm (7 x 10in).

'IN SEARCH OF PETER PAN'
© 2001

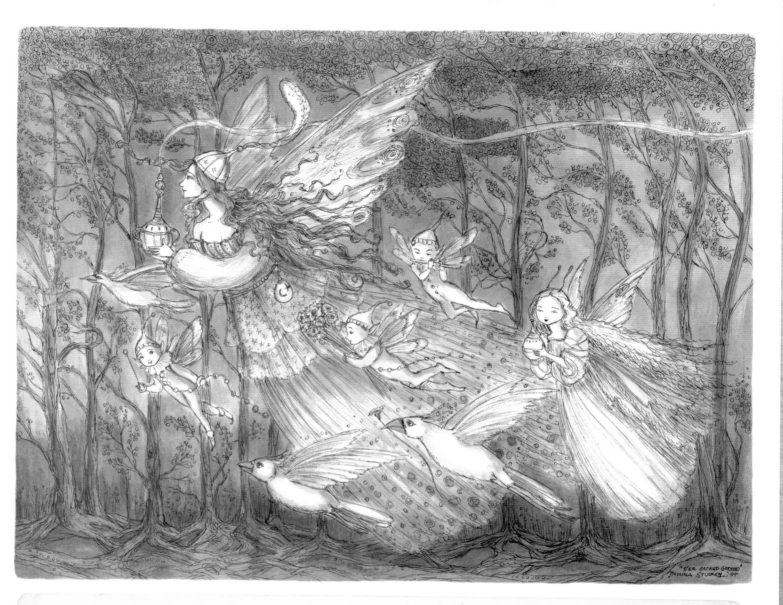

"O'ER SACRED GROUND"
PAULINA STUCKEY '04

RULE

75

Keep a sketchbook

Sketch for at least 20 minutes every day. Outdoor locations are best for energy flow; being surrounded by the rhythm of nature lifts the spirit, inspiring ideas and offering a fresh, creative perspective.

RULE

76

Record your dreams

Dreams offer access to not only your deepest subconscious, but also to alternate dimensions. Amid your dreams, you often meet the most interesting beings, and visit the most fascinating worlds along the way. Write your dreams down (or sketch or record them) immediately upon waking, as this is when they are most clear.

Meredith Dillman

Meredith's fantasy and fairytale art career took flight when she was young and given to making squiggles on paper. In the time since, she has come to appreciate as inspiration the paintings of the Pre-Raphaelites, the organic flow of Art Nouveau, and the balance of Japanese art. Her paintings have become progressively more detailed and colourful. She has authored two books to date, *Watercolour Made Easy: Fairies and Fantasy* and *Fantasy Fashion Art Studio.*

I enjoy painting fairies combined with subjects from nature. I love gardening, so flower and leaf inspirations are always easy to find. My favourite artists include Alphonse Mucha, Uemura Shoen, Edward Burne-Jones, Dante Gabriel Rossetti, and Warwick Goble. My favourite art inspires my compositions. I use creative Art Nouveau-inspired borders as frames to surround a main figure or tie a series of paintings together. Studying asymmetrical Chinese and Japanese paintings reminds me that not every bit of the canvas needs to be filled. My favourite watercolours to use are M. Graham professional watercolour paints. I like them because

they make strong colours and don't dry out completely when I put them in my palette. I prefer to paint on smooth watercolour blocks so that I can use ink pens for small details and avoid stretching paper. When I begin a painting, I make a colour study over a sketch to decide which colours to use. I like to stick to an analogous palette like warm sunset colours or a green forest scene. It's not easy to know when I am done with a painting. When I am tired of looking at it and I can't think of anything else to add, I will stop. I have to put the painting away and look at it the next day. When I scan it into the computer, I often notice things I want to change.

▲ **Tree Fairy**
The swirling lines of the branches of the tree complement those of the fairy's dress and hair. They also frame the fairy and direct the eye back towards the figure.

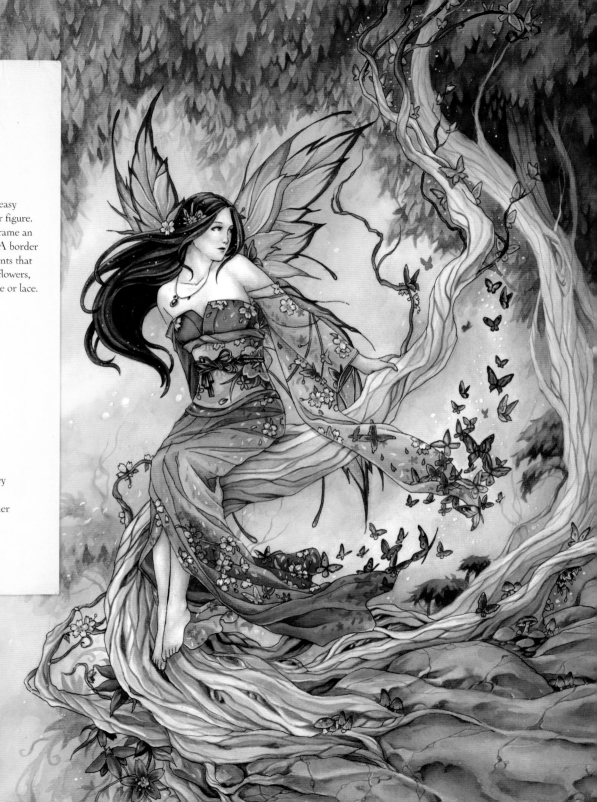

22·5 ×17

RULE
77
Frame your subject

Adding a border to your painting is an easy
way to draw attention to and frame your figure.
Use a decorative border on its own or frame an
entire scene with a background within. A border
can be simple lines or made up of elements that
echo the theme of the painting, such as flowers,
vines, branches, stonework, metal filigree or lace.

RULE
78
Be creative with colour

Objects don't have to be the colours they
are in nature. Make tree trunks green
or leaves purple to tie everything together
with a unifying colour scheme.

➤ **The Edge of Enchantment**
*This is a magical scene where
butterflies are born from the
pattern on the fairy's kimono-
inspired dress. I mimicked the
sunset colours of her dress in
the sky and trees.*

Amy Brown

Fantasy artist Amy Brown resides in the Pacific Northwest, along with various annoying house goblins and pesky pixies. She loves working in watercolour because she feels the medium lends a luminous spark of life to the creatures she paints. Plus, watercolours are non-toxic to fairies, who tend to get into everything.

When I begin a piece, I rarely have a fully formed idea of what I want the painting to look like when it's completed. I prefer to keep the image a surprise for as long as I can. When I have sketched a basic idea I like, I transfer the rough sketch to the watercolour paper via my light table. After the basic sketch is down, I place a sheet of tracing paper over the sketch and draw clothing, hair styles, and background elements onto the tracing paper. Sometimes I use several sheets to play with various ideas. Once I've decided on the direction I want to go with the painting, I return to my light table to transfer the chosen elements to the watercolour paper. Then I refine the drawing and sit back to ponder the colour palette.

I dislike choosing colour palettes. There are far too many wonderful colours to choose from. I generally try to keep the palette simple and limit it to three or four colours that complement each other. I can then expand the palette by varying the shades of the chosen colours.

Once the colour palette has been chosen, I prefer to paint the background first. A lot of artists start with the main figure. I am the type of person who eats my vegetables first and saves the entré for last, to savour. I paint the same way. I am most interested in the main character (the entré), so I paint the background first and save the character for last. When painting the main character, I usually start with the skin, then the clothing, hair and finally the wings. Each section is built up with several layers of paint. Lastly, I add white highlights with opaque white gouache.

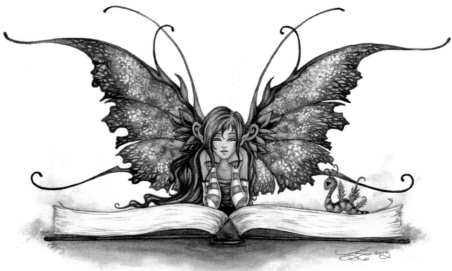

► Book Worm
The pose I used for this piece allowed me to get really creative with her wings and make them the focal point. The little worm fellow to the right adds an additional element of whimsy.

RULE

79

Try new techniques

Don't be afraid to take risks. Will you fail on occasion? Absolutely. And that's perfectly OK. You won't make great discoveries if you never venture out and try.

RULE

80

Think outside the box

Imagination has no boundaries. We want to see something magical that we have never seen before. Show us something that will spark our own imaginations.

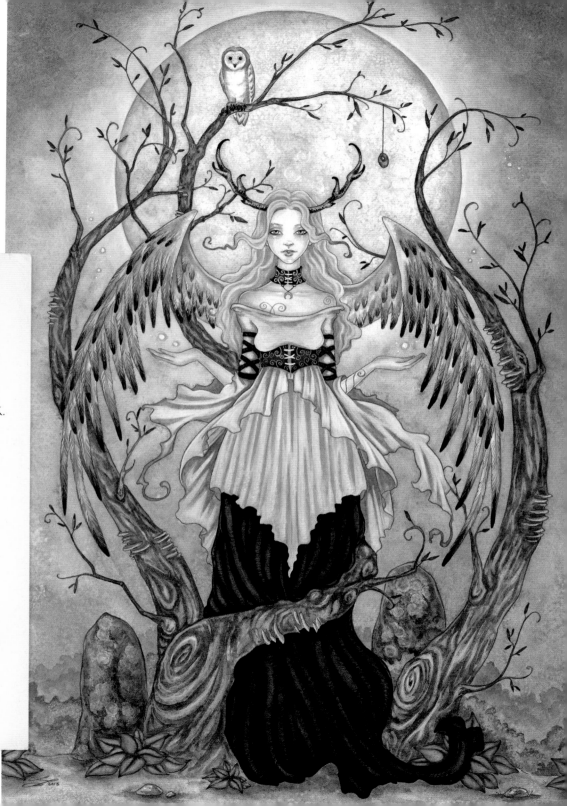

Index

Credits

I would like to thank Victoria, Kate and the entire crew who worked closely with me on this project. It was a great experience and opportunity to put my teaching into words on paper. Thank you to my strong and patient husband, Brian, for his late-night contributions, for watching our daughter so I can work and for his quick, clever ideas, and critiques. Brian, you are my rock. And I'd like to thank my close and dear friends for their input throughout this entire process. How blessed I am to have so many within my circle and to have so much support in what I love to do.

This book is dedicated to my daughter, Norah.
Let your imagination and light dance!

Quarto would like to thank the following artists for supplying images for inclusion in this book:
Bromley, Joanna, www.joannabromleyart.com, p.55r
Brown, Amy, www.amybrownart.com, pp.126–127
Browne, James, www.jamesbrowne.net, pp.120–121
Cassidy, Paulina, www.paulina.ws, pp.122–123
Fenech, Selina, www.selinafenech.com, p.31
Flinkfeldt, Kajsa, flingling.deviantart.com, p.113
Gyseman, Suzanne, www.suzannegyseman.co.uk, pp.42tr, 100
Jeffrey, Julia Helen, www.stonemaiden-art.com, pp.116–117
Kelly, Becky, www.beckykellystudio.com, pp.114, 118–119
Ravenscroft, Linda, www.lindaravenscroft.com, p.59r

Special thanks to Meredith Dillman
(www.meredithdillman.com, www.woodlandfancies.com)
for supplying the artwork and text on the following pages:
pp.40–43, 56–59, 76–79, 92–95, 101–103, 106–109, 124–125

Other images courtesy of:
Ambient Ideas, Shutterstock.com, p.37tr; BMCL, Shutterstock.com, p.40b; Lockstock, DevianArt.com, p.35b; © Macmillan, p.41tr; Moroz, Evgeniya, Shutterstock.com, p.14bl; Rovagnati, Julian, Shutterstock.com, p.68c; Scisetti Alfio, Shutterstock.com, p.40bcl; SenshiStock, senshistock. deviantart.com, p.34br; Serg64, Shutterstock.com, p.40tcr; Shutterstock.com, p.14br; Triff, Shutterstock.com, p.14tl

All other artwork by Sara Burrier.

All step-by-step and other images are the copyright of Quarto Publishing plc. While every effort has been made to credit contributors, Quarto would like to apologise should there have been any omissions or errors – and would be pleased to make the appropriate correction for future editions of the book.